WHAT PEOPLE ARE S

DRONE AND AF

Demers' text is a wide, rooted journey through interpretation and imagination, a fine example of the importance of listening with an open mind.
Will Long, founder of drone group Celer

Some say that art is the postponement of the end of the world, and the curious effect of the obliquity of these intriguing critical-musical fictions is to slow down the onrush of the apocalypse they keep fantasizing, decelerating it to drone speed, to allow us to appreciate it. Drone is thingly music, and apocalypse speech fantasizes that you can rip the appearance away from things, to reach the reality. Joanna Demers's intricate, cycling filigrees of fiction and history and philosophy and music analysis prevent this rip from occurring, preserving the mysterious reality of things, a reality that science, STEM speak notwithstanding, is prevented from disclosing.
Timothy Morton, Rita Shea Guffey Chair in English, Rice University

This is an astonishingly rich book. The depth and range of Demers' fields of reference and the insights of her musical discussions make her account a marvelously productive true fiction. This is essential reading for anyone interested in contemporary music.
Mitchell Morris, Professor of Musicology, UCLA

At the end of the film adaptation of Chuck Palahniuk's novel, *Fight Club*, the narrator watches a skyscraper's collapse set to the sounds by The Dust Brothers. This self-fulfilled cataclysm is

echoed by the (fictional) protagonist of Joanna Demers' *Drone and Apocalypse*, but unlike the breakbeat rhythms of this Hollywood depiction, Cynthia Wey's soundtrack is appropriately composed of the music by Celer, William Basinski and Éliane Radigue. The inevitable demise of humanity is explored through a series of essays that reflect on man-made catastrophes, spiritual holocaust, and ultimately, void. But unlike the negative connotation of the words marking the end of our own existence, Demers reveals the beauty of emptiness, expressed by the drones drenched in longing and time. This concept of eternal spaciousness has long been known in the Buddhist absolute. Demers' work invites the reader (and the listener) to enter the space of unending apocalypse, submerging oneself in a lasting nostalgia for our eminent fate.

HC, from Headphone Commute, an independent online magazine covering electronic, experimental and instrumental music

Joanna Demers' book is a creative and speculative mission into the lush hinterlands at the edges of academic writing. It is a fascinating exploration of drone, noise and the ends of the comprehensible.

Robert Willim, Lund University, Sweden

Drone and Apocalypse

An Exhibit Catalog for the End of the World

Drone and Apocalypse

An Exhibit Catalog for the End of the World

Joanna Demers

zero
books

Winchester, UK
Washington, USA

First published by Zero Books, 2015
Zero Books is an imprint of John Hunt Publishing Ltd., Laurel House, Station Approach,
Alresford, Hants, SO24 9JH, UK
office1@jhpbooks.net
www.johnhuntpublishing.com
www.zero-books.net

For distributor details and how to order please visit the 'Ordering' section on our website.

Text copyright: Joanna Demers 2014

ISBN: 978 1 78279 994 8
Library of Congress Control Number: 2015930444

A CIP catalogue record for this book is available from the British Library.

Design: Stuart Davies

Printed and bound by CPI Group (UK) Ltd, Croydon, CR0 4YY, UK

We operate a distinctive and ethical publishing philosophy in all
areas of our business, from our global network of authors to
production and worldwide distribution.

CONTENTS

Also by Joanna Demers

Steal This Music: How Intellectual Property Law Affects Musical Creativity. Athens, GA: University of Georgia Press, 2007.

Listening Through the Noise: The Aesthetics of Experimental Electronic Music. New York: Oxford University Press, 2010.

Explore the exhibit in its entirety at:
http://www.joannademers.com

To Inouk and Nola

Preface

...art's vocation is to unveil the truth...

GWF Hegel, Lectures on Aesthetics

...for sudden, the firm earth was shaken
As if by the last wreck its frame were overtaken.

Percy Bysshe Shelley, "Laon and Cythna"

At a speaker series event in the department where I teach, a guest medievalist gave a talk on troubadour songs. She sang a few examples and pointed out intricacies of rhyme and ambiguities of meaning. And then she acknowledged a fact that often intimidates young musicologists away from medieval studies: troubadour notation does not indicate rhythm or duration, so it is impossible for us to know exactly how this music sounded, or as she put it, is supposed to sound. And this aporia meant that we could never argue for any connection between music and lyrics, nor for any musical as opposed to textual meaning. Troubadour songs, in other words, would remain unfathomable and unperceived, an ideal of music with no satisfying reality to anchor it.

Still, she didn't want to give up. She brought out some diagrams indicating where peaks in the melody corresponded to poignant moments in the text, hoping to discern some material trace linking music with meaning. Failing to find any such relationship, she concluded that we must be missing some crucial bit of information. She admitted that it would be distasteful to accept that there might be nothing there, no sense or meaning to this beautiful music she so loved. And so she perhaps unknowingly settled upon the conclusion that musicol-

ogist Carolyn Abbate derives from Vladimir Jankélévitch's writings on ineffability, that music's power manifests through performance rather than notation.[1] Music is drastic rather than gnostic. The medievalist closed by speculating that we have only to unearth a contemporaneous account of a performance that will reveal how troubadour music sounded and what it signified.

This musicologist's frankness about the limits of our knowledge of medieval music was both deflating and refreshing. Fifteen years before, I had decided against a research focus on early music on the basis of the unknowability of music of the distant past. Leaving the Middle Ages for what I presumed were the more navigable waters of the present, I fell in love with electronica and drone music, especially noise and drone works by such artists as Celer, William Basinski, Tim Hecker, Thomas Köner, Les Rallizes Dénudés, and Éliane Radigue. I wrote a monograph on the aesthetics of electronic music, and offered a few defensible interpretations. A few years later, I wrote an essay on meaningless moments in popular music.[2] And here, I mentioned the incommensurability of drone music with the writing about drone music, the discrepancy between the great duration of these works and the dearth of words we can use to describe music that seems to change so little. I enlisted Abbate, Jankélévitch and Susan Sontag in calling for a type of writing that honors the meaninglessness of recent music, the examples of beautiful or ugly or just jarring music that affect us physically. These moments are empty because they cannot be interpreted, but they may help us understand philosophical dilemmas. Thus, instead of using theory to decode music, we can use these meaningless moments as points of entry for philosophy. The essay is a teaser, and my question "What on earth would such a project look like?" goes unanswered; I planned on responding to it in my next book.

But drone music, however lush and evocative, does not give up its meaningless moments so easily. Although recordings allow

us to know instantaneously how this music sounds, we know hardly more about drone music's meaning than we do about the meaning of troubadour songs. I realized this when in 2012 I corresponded with Will Long, one of two founding members of the ambient drone act Celer. I asked Long whether there were affinities between Celer's album *The Everything and the Nothing* (2008) and philosophy, and he answered:

> We actually had very little if anything in mind related to philosophy to connect with the music, but the fact that it is possible to relate it to that is important, and what I hope most is that each person can find something to connect it to for themselves.[3]

Long's response disquieted me. I had been sure that Celer's music had some philosophical grounding to it, and my certainty was borne out by Celer's track titles (often poetic and referring, so I thought, to philosophy and critical theory) as well as the atmospheric qualities of the sounds. But Long's answer made me reconsider a conventionally scholarly approach toward drone music. Celer's music is indeed personally meaningful to Long, but that meaning is not binding for anyone else. The discrepancy between the length of drone recordings and live performances (often surpassing an hour) and the paucity of words we can use to describe this music makes any claims at interpretation suspect. No secret message, no code, nothing to interpret. Nothing, even in the midst of everything beautiful.

Fortunately, this is a good time for music scholars interested in ineffability. The 2012 colloquy in the *Journal of the American Musicological Society* invited several musicologists to reflect on Jankélévitch's contributions to music and philosophy, and much of this discussion nuances Abbate's pronouncements about the ineffable as something unknowable and inscrutable.[4] As Steven Rings points out, Jankélévitch states that music's ineffability

paradoxically galvanizes endless types of writing about its communicative capacity.[5] Yet as James Hepokoski notes, Jankélévitch distinguishes between things meant to be talked about and things "meant to be done", with "those things in relation to which purely expressive language appears so secondary, so unconvincing, so miserably inefficacious, are the most important and most precious things in life."[6] This fuller picture of Jankélévitch's pronouncements on the ineffable leave us with a rare opportunity as scholars to finally practice what an esteemed thinker preaches. Yes, music is slippery, resistant to deciphering, and perhaps eternally unknowable. However, it is also a magnet for words as well as for actions, for gestures that put into practice dilemmas and questions that philosophy tackles only in theory. If we momentarily turn from the aspect of Jankélévitch's approach that emphasizes what music does not do, namely, communicate prosaically, what remains is that which music *does* communicate, a vague terrain that has intrigued thinkers ranging from Plato to Hegel, Schopenhauer, and Badiou. Of these philosophers, Hegel is especially explicit: his aesthetic theory has it that music as a form of art unveils truth.[7] The content of that truth is less at stake than the formidable power of that idea, that music and art unveil something hidden.

Drone and Apocalypse answers Jankélévitch's call for a definitive action that acknowledges the ineffability of music through doing rather than just writing. Since drone music is especially difficult to read and interpret, we may well already have arrived at a point where there is nothing substantially new to say about it, and certainly nothing definitive to say about its content. We could continue to talk about the production of drone music, or its history and reception. Or, we could experiment with the ways it simultaneously evokes and deflects meaning. I have therefore made the decision to write a literary non-fiction work rather than one based exclusively on research or criticism. *Drone and Apocalypse* is the next step in my scholarship on the aesthetics of

recent electronic music. My methodology is to relate technical qualities of specific drone works (aspects like space, duration, repetition, and register) to pertinent moments in literature, philosophy, and art. These skeins of associations are ahistorical and poetic, but they are informed by a musicological and aesthetic reading of drone music. *Drone and Apocalypse* is thus a creative work that requires a fictional premise as its starting point. The book assumes the form of an exhibit catalog for an art show that takes place some two hundred years from now. The exhibit, "Commentaries on the Apocalypse", showcases writings and artworks of Cynthia Wey, a failed artist who during the early twenty-first century wrote critical essays relating ethics and aesthetics to drone music as well as ancient, classical, and medieval literature. Wey also created several "speculative artworks", her term for descriptions of artworks that she never realized. The theme of both the essays and speculative artworks is apocalypse, because Wey was convinced that the end of humanity was imminent and would be triggered by some cataclysmic event. Her subjects range from ethical (is it right to enjoy doomsday art? should art give the illusion of free will?) to aesthetic (why are lists so central to apocalyptic art?). The curators who recover her journal stage an exhibit that mounts materialized versions of the speculative artworks, which in turn draw on the essays for their conceptual grounding.

I anticipate at this point skepticism on the part of some readers. Why should an academic employ a fictional premise and creative methodology to tackle what is, let's be honest, a scholarly quibble? And why bring apocalypse into the discussion? In response to the first question, while this book does depart radically from the disciplinary conventions of musicology, it is not without precedent. The journal *Current Musicology* in late 2012 circulated a call for "experimental writing" on music, and one essay from this book was published in that issue.[8] Examples of experimental scholarship in the

humanities at large include Tim Mulgan's monograph *Ethics for a Broken World*, a philosophical exploration of the ethics of apocalypse that assumes the fictional role of a series of university lectures delivered at some point after a catastrophic environmental event has decimated the world's population,[9] or Reza Negarestani's *Cyclonopedia*, an amalgam of critical theory and fiction centering on the politics of petroleum.[10] One could also turn to W.G. Sebald, the novelist and poet who was also a professor of European literature, as the preeminent re-inventor of literary non-fiction. In Sebald's work we find writings that are at once travelogues, histories, essays, poems, and novels. This generic hybridity enriches ruminations on migration, loss, memory, and trauma. Jankélévitch may now be recognized among musicologists as someone who gives us license to celebrate what is inennarrable in music, but it is thanks to writers like Sebald that we can even consider bridging the gap between academic research and creative writing.

But that still leaves the second question: why is apocalypse relevant to a discussion of drone music?

Why Apocalypse? Why Drone Music?

To respond, I would turn to Low's song "Do You Know How to Waltz?", which caused a small controversy when the band played it (and it alone) for twenty-seven minutes during its set at the Rock the Garden Festival in Minneapolis on 15 June 2013.[11] This song, which Low first recorded in 1996, is divided into three parts, the first and last seething as slow-burning drones of bass guitar, electric guitar, and percussion.[12] The middle section consists of a lugubrious dirge whose lyrics refer to one last opportunity to dance before an inevitable reprisal, the time to "pay the debt." The track is grim, and is beloved among Low fans. But some concert attendees complained that Low cheated the Rock the Garden audience out of a decent show. At the end of the performance, Alan Sparhawk looked furious. He may well

have been exhausted after the twenty-two minute escalating drone that formed the third part of the song, a crescendo that required repetitive strumming and cymbal rolls and razor-sharp concentration. Sparhawk must also have been fuming at the distracted public, those passersby who ditched Low's stage for something more upbeat or who remained to text or take pictures instead of listening. After the song reached its end in a cascade of noise, Sparhawk took off his guitar, bent down to the microphone and, instead of thanking the audience, yelled "Drone, not drones", poking his finger in the air with the vehemence of the righteous.[13] Whether Sparhawk's anger was directed toward the audience or toward the architects of flying weapons is of less consequence here than the fact that this performance so eloquently elided drone music ("drone") with apocalypse ("drones"). Drone music excels in creating and maintaining tension. It aestheticizes doom, opening a door onto once and future catastrophes, those that are imminent and those that, once believed to be imminent, are now detours in a past that turned out otherwise.

It might seem contradictory to state that drone music is apocalyptic if it cannot even be interpreted. But apocalypse itself is a phenomenon that flouts interpretation; it is a literal rendition of the ineffable, something that exceeds or evades or defies speech. Apocalypse as cataclysm draws a line between the present and the future, presence and absence. It is an emptiness, a threat or a hope of a revelation ("apocalypse" literally means "unveiling"), but it is unthinkable insofar as we cannot claim to have already lived it. Apocalypse in modern parlance is a dreadful thing to contemplate, even though it is not clear what exactly will expire once apocalypse has happened. We may think of apocalypse as the end of the world, or the end of humanity. But apocalypse needn't necessarily be either, for humanity's apocalypse could well consist of being reduced to living in pre-industrial conditions. This would be a drastic turn of events,

surely, but not so much an apocalypse for our species as for our culture and technology. The meaning of "the end of the world" is even obscurer, for even the most pessimistic anticipations of apocalypse tend not to proclaim that Planet Earth will disappear. What, then, will end? A hyperobject as conceived by Tim Morton, apocalypse is something we can theorize or foretell, but not know in its entirety.[14] We know of it only obliquely through works of art that speak of it (such as Basinski's *The Disintegration Loops*) or that speculate about its attributes (such as Basinski's *The River*). And while I agree with Morton that the end of the world has already occurred because "world" means a series of ideas about what life should and should not be,[15] we should nonetheless understand that the recent usage of "apocalypse" indicates a belief that the worst is yet to come, that apocalypse is an event from which humanity will not emerge. This sense of "the end of the world" is aesthetically significant, for as this book demonstrates, it drives much of our art and culture and feeds our political malaise and spiritual cynicism. The writer Cynthia Wey takes apocalypse literally to mean the end of human existence on Earth, although she acknowledges the inherent narcissism in apocalyptic theories that harp on humanity's disappearance to the exclusion of any other object or being. Many of us share Wey's parochial notion of apocalypse, for we assume that if we ever do experience apocalypse, it will be just as we are about to disappear.

Drone music is the sound of death. Consider drone works named with death in mind: *Trilogie de la mort*; *Ravedeath, 1972*; and more abstractly, *The Disintegration Loops*, where disintegration means death of magnetic tape, the World Trade Center, and the American empire. There is also the fact that the sounds of the beginning of life in the womb consist of low hums and heartbeats, an enveloping sonic blanket undergirds experience and sensation. (Drone artist Éliane Radigue created a work in 1974 called *Biogenesis*, which consists of recordings of her own

8

heartbeat and the heartbeat of the baby she was then carrying). Thus, drone is also the sound of life at its inception, for Celer's music in its sparest moments (such as in the albums *Merkin* or *In Escaping Lakes*) recalls the womb's protection and comfort. Drone music's paucity of activity or events such as cadences, solos, figuration, or expressive gestures shakes off conventional musical interpretation, yet also exists as a music of afterness, that which resounds after machines and chatter have died off. Drone music is a music for when the markers of time such as clocks, metronomes, alarms have stopped. It is an acoustic foundation from which other sounds emerged, and to which all sounds will eventually return. Just as apocalypse is an ending, drone music often taxes listeners' sense of time and duration, as well as space and distance.

Drone and Apocalypse excavates the traces of apocalyptic dread and longing that pervade not only drone music, but literature and philosophy and art since antiquity. For apocalyptic dread has never been far from human consciousness. Cynthia Wey's absolute faith that the end is nigh spurs her to make connections between Japanese noise drone and the anticipation of catastrophes that have never materialized. She hears indications in the litanies of repetitive sound in Celer and Basinski of manifests, testaments of possessions and accomplishments undertaken in the event of calamity. Wey unmasks the cynicism of contemporary art as nostalgia for metaphysical order, and contrasts such cynicism with the bravery of drone works that acknowledge the metaphysical void. And she indicts humanity's desire for apocalypse, our talent for aestheticizing suffering and dying on a mass scale.

Speculative artworks are Wey's attempt to make art out of her observations of the art around her. Her works never progress beyond descriptions; it is only through the labor of curators residing far in the future that they are finally realized. Apocalypse is terrifying because it is the collision of potential

and kinetic energies, the force it takes to destroy coupled with the force that will never have the chance to be expended. The curators who in turn realize Wey's descriptions scrimmage with these speculations, both representing and chafing against that which she imagines.

* *

To enter the exhibit, begin with the "Curators' Introduction", in which curators from the future introduce Cynthia Wey and explain their reasons for staging the exhibit. Proceed then to Wey's own introduction, "Commentaries on the Apocalypse", which argues for the prevalence of apocalyptic anticipation and desire in early-twenty-first-century art and drone music. At this point, feel free to wander from essay to artwork, from text to website to recording to photograph.

In the essay "The End of Happiness, The End of Hope", Wey considers Herodotus' *Histories*, a text that most know as a description of the longstanding feud between Greeks and Persians during antiquity. Wey is drawn instead to Herodotus as a travel writer and philosopher. The *Histories* asks two questions of us: what is the end of human life, and what is the end of the world? Wey plays with meanings of "end" (purpose, furthest point, and ceasing-to-be), and constructs an unlikely connection between ends in Herodotus and those implied in the drones of Celer and Thomas Köner. The ambient drone artist Celer works with voluptuous looped harmonies that propose an alternative to the Hellenic wisdom that a life can be judged as happy only at its end. Celer proves that we can experience a lifetime's worth of happiness in a single instant, especially if that instant is all that is left for us. Köner works with low, quiet field recordings of the Arctic. His recordings pinpoint what in geographical extremes fascinates and horrifies us. Herodotus' tyrants spill blood because they want to conquer, but also because something

compels them to push their armies beyond where any prede-
cessors had invaded, to occupy that which maps and hearsay
claim is empty. Such compulsion is vertiginous, a fear of and
desire for unmapped, unintelligible wilderness.

Drone music can consist of a sustained tone, as in the works
of Radigue, or it can exist as repeated or looped materials, as in
the works of Basinski and Celer. It is probably impossible to
speak credibly about the meaning of repeated materials, for what
meaning can a single chord or pitch possess? Wey's essay
"Manifest" points instead to the process of drone music, a type
of list-making that recalls inventories in apocalyptic moments in
Isidore of Seville and Robert Burton. Manifests are common in
melancholic art; the very act of listing is melancholic in that it is
a manic attempt at documenting with full awareness of the
impossibility of the task. Wey demonstrates that the manifest is
an apocalyptic device, an account undertaken when the end is at
hand. Isidore's *Etymologies* was a seventh century fallout shelter
for Roman-Spanish civilization, a manual for rebirthing a way of
life on the verge of ruin. Basinski's and Celer's manifests also try
to account for the total, of the melancholic or the beautiful,
before the end that their repetition telegraphs.

In "Radigue's Wager", Wey confronts the cynicism of contem-
porary art that takes the form of depictions of ugliness or pain.
Such cynicism for Michel Houellebecq is the very premise of
recent art, and for Morton is concomitant with today's liberalism,
a latter-day incarnation of Hegel's "beautiful soul". But
cynicism's prickliness conceals a profound desire that the world
be other than the way it is. With Adorno, today's artworld cynics
believe that the only way to remain faithful to beauty is to reject
beauty. Wey regards imminent apocalypse as the only means to
shake entrenched cynicism. But cynicism's supposed opposite,
naiveté, is equally unacceptable. Wey argues that Pascal's wager
(we stand to gain more from belief than from non-belief) is itself
cynical, and locates its antidote in the music of Radigue, whose

spartan drones are neither populist nor elitist, consonant nor dissonant. There is nothing to be lost or gained in the music of Radigue, and for that reason, it is more attuned to impending apocalypse than abject art.

With "Apocalyptic Desire", Wey interrogates our fascination with death and doomsday scenarios. It might be tempting to think of this as a uniquely contemporary condition, but Plato mentions a man who could not keep himself from looking at the corpses of executed criminals. If apocalyptically themed art is compelling, it is so because apocalypse is simultaneously terrifying and desirable. Inevitability is enthralling, whether it is found in a tragic novel or a recording to which we return repeatedly. Boethius, imprisoned for treason and awaiting execution, contrasted the fickle affections of Fortune to the peaceful harmony of God, who organizes celestial bodies along with humanity in an orrery of order. Tranquility comes to those who reconcile themselves to Fate, who do not attempt to break out of its orbit. But the drama in the works of Tim Hecker lies in precisely this, that although we may know full well of the end in life or art, we pretend that it is otherwise and indulge in the illusion of determination. And when we return to artworks that treat apocalypse, we use as an alibi our belief in the illusion of freewill to cover up our enjoyment of others' suffering. Aristotle and Edmund Burke explain this pleasure as catharsis or Schadenfreude, respectively, but the positive reception of Basinski's *The Disintegration Loops* puts forward the intimation that hopeless situations possess intrinsic beauty.

Wey's final essay, "After Apocalypse", treats our infatuation with the aftermath of cataclysmic events. Post-apocalypse should be an oxymoron, for we can write no afterword to our own extinction. Yet Cold War culture abounded with post-apocalyptic stories, and Basinski's *The River* imagines the future divested of humans. The Japanese noise-rock group Les Rallizes Dénudés enlisted feedback, Marxist propaganda, and terrorism in its

explorations of past and future megadeath. This essay walks among the ruins of military installations built in anticipation of nuclear war, and listens to music predicated on the aftermath of one nuclear trauma and the imminence of the next, final one. How can we remain conceived of a past or a future from which we are utterly absent?

Interspersed between Wey's essays are her speculative artworks ("The Big Bang", "Photojournalism of the Fall", "Pump Cam / Debt Clock", and "The Chelyabinsk Meteoroid"). Each speculative artwork begins with Wey's description, and follows with the curators' description of how they realized the work. "Photojournalism of the Fall" features the photographs of the exhibit; in reality, these are original works by the artist Sean Griffin. The other speculative artworks refer to content that is accessible on my website, http://www.joannademers.com. Please make full use of this website, as it displays the full assortment of visual and video art and music described in the catalog.

* *

I am grateful to William Basinski, Richard Chartier, Julian Cope, Kyle Bobby Dunn, Nina Eidsheim, Adam Gilbert, Rotem Gilbert, Luisa Greenfield, Sean Griffin, John Mark Harris, Headphone Commute, Tim Hecker, Norm Hirschy, Craig Hoover, Sue Hoover, Thomas Köner, Norman Krieger, Will Long, Tim Page, Lise Patt, Scott Paulin, Kasra Paydavousi, Éliane Radigue, Matt Shlomowitz, Jim, Joan, and Ed Spratt, Ming Tsao, Roxanne Varzi, Jo Webber, Peggy Webber, and Mandy-Suzanne Wong. Most of all, Inouk and Nola Demers.

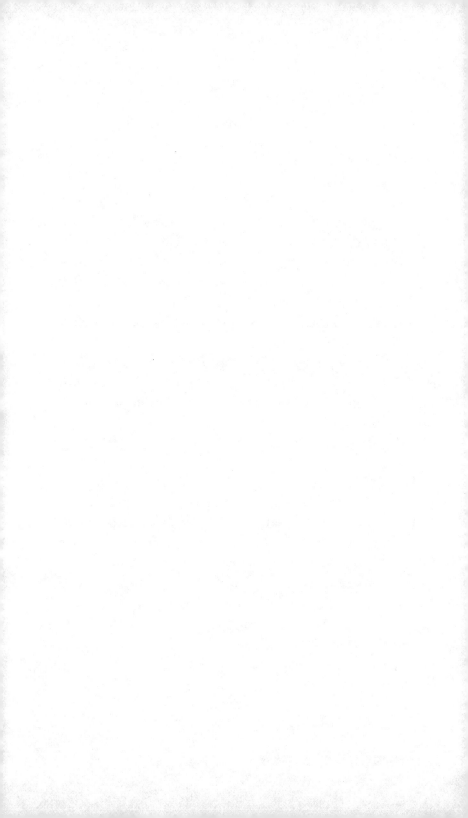

Commentaries on the Apocalypse

An exhibit of early-twenty first century art and drone music featuring essays and speculative artworks by Cynthia Wey

14-28 October 2213

Center for Humanistic Study

Los Angeles, California

Curators' Introduction

Cynthia Wey is not known for being a philosopher, nor until now, an artist. Beyond a few paintings submitted for her degree requirements, she created no physical artworks at all. Nor did she publish any of her writings, nor even circulate them among friends. Wey, in other words, would seem to be of no consequence to humanists studying the early-twenty first century. Yet within her journals that she kept religiously from the age of 24 to her death at the age of 54 are housed some of the most idiosyncratic insights on the philosophy of the art of her era. Some of these observations are conveyed through her essays, others as "speculative artworks", her term for art objects that exist only theoretically, as textual descriptions.

We know a few details of Wey's biography: born in 1984, she grew up in Rancho Palos Verdes, an affluent coastal suburb 20 miles south of Los Angeles. She started violin lessons at the age of six, played in local youth orchestras, and gave occasional recitals. She attended Harvey Mudd College for one year with the intention of majoring in computer science, but transferred to Pomona College to study art history. She graduated in 2006, worked in a non-profit philanthropic agency for two years, and in 2008 started an MFA at Cal Arts in photography and video art. Having finished that degree in 2010 in the height of a recession, she made what were evidently half-hearted and poorly received attempts at breaking into the Los Angeles art scene, before taking a job as an administrative assistant at UC San Diego. She worked briefly in the Visual Arts Department before landing in the Music Department, where she remained until her death. Her job consisted of preparing payroll for faculty, staff, and graduate students.

This is the same sort of biographical boilerplate we might unearth for any American living at the beginning of the twenty

first century, although she seems unusually free of many of the blights of her generation. We have found no evidence of any medical concerns. She took no anti-depressants, and doesn't seem to have seen a therapist. She used no social media. Once a year from the time she was 30, she took a two-week summer vacation in Bali, where she attended a yoga retreat in the town of Ubud. We know nothing about any lovers or spouses, children, pets, friends, religious beliefs, or political affiliations. We do know that she was struck and killed crossing the street while walking from a parking lot to her office. We surmise that she led a happy life, or at least a contented one. We can also speculate that much of Wey's waking life was spent thinking about what she would eventually write in her journals, usually at night between 8pm and 10pm and occasionally early in the morning, between 5am and 6am. Her records on this point are brief, but exact. Her journals contain nothing of the usual diaristic fare, no complaints or soul-searching, no poems about unrequited love. Instead, they house a comprehensive investigation of art's commentaries on the end of the world, an event she was convinced was imminent.

Wey was not alone in this belief; mass human extinctions, eschatological visions, and apocalyptic hysteria have waxed and waned throughout human history. A particularly acute case flared up in the late-twentieth and early-twenty first centuries, when apocalyptic paranoia could draw justification from nearly every quarter of human existence. Nuclear war was a threat left over from 1945. Terrorism, already present in the Middle East, Asia, Africa, Central and South America, and Europe for most of the twentieth century, arrived in a great media spectacle in the United States in 2001. Aside from violent conflict, other catastrophes fueled apocalyptic anxiety: climate change wrought by carbon production, bacterial outbreak, famine, solar flares, technological malfunction, meteorite impact, seismic activity. All of these were plausible threats. Some religious groups preached

that a deity would destroy the earth in order to punish some or all of humanity. Considering the wealth of the twenty first century, the fact that never before or since have so many humans enjoyed such a high standard of living, it is remarkable that so many believed in the inevitability of the end. Film and television, literature, music, and art relied on apocalypse as a thematic touchstone, but as Wey demonstrates, apocalypse saturated art to its very core, generating techniques ranging from list-making to noise-production. The stuff of twenty first century art is profoundly end-oriented.

But while so many of her contemporaries were complacent in accepting apocalypse, Wey questions every aspect of the end-times, from both ethical and aesthetic standpoints. Her certainty of imminent end spurred her to address questions such as: Why does so much apocalyptic art consist of lists? What is the point of life when death is at hand? Why are apocalyptic premises in contemporary art and mass culture so popular, and should we feel disgusted when we enjoy them? Why, in other words, do we experience apocalyptic desire? And in the face of the end, do we still possess freewill? Wey poses these questions via canonical philosophical and literary texts, especially Herodotus' *Histories*, Aristotle's *Nicomachean Ethics*, and Robert Burton's *The Anatomy of Melancholy*. Her responses to these questions draw from the scattershot assortment of literature she deploys, but they ultimately center on a particular form of contemporary music called "drone" that was evidently very dear to her, filling the pages of her journals and forming the backbone of her aesthetic sensibilities.

Accounts from this period state that drones were prevalent in non-European musical traditions as far back as records go, and that European and neo-European artists began to make drones of various sorts starting in the 1950s. La Monte Young is the artist usually credited with introducing drone to Western experimental music. But the category of "drone music" in these accounts is too

vast to be of much use to us here. Drone music could be loud, sustained cacophony, or quiet intermittent repetitions of the same few sonorities. Drone music could be intended as a bridge toward spiritual ecstasy, or as a way of enhancing melancholy or madness. It appeared in mainstream and experimental film soundtracks, popular music and rock, and electronic music. We must conclude that drone's ubiquity in twenty first-century culture resulted from the music's ability to recede into the background. Unless it was very loud or dissonant, drone music could pass unnoticed amid other images or events. Many described it as the best sort of ambient music, an acoustic wallpaper that could imply a mood without imposing a message. But drone music could also be deafening and disruptive. We hear in drones both loud and soft, soothing and aggressive, confirmation that something has stopped, or that something is about to stop. Drone music is liminal, a straight line of sound that marks the edge between the present and future, presence and absence, essential and incidental.

We have organized this exhibit catalog as a realization of Wey's "Commentaries on the Apocalypse", critical essays on specific drone works by Wey's most beloved artists, Celer, William Basinski, Tim Hecker, Les Rallizes Dénudés, Éliane Radigue, and Thomas Köner. Interspersed amid these essays are Wey's own textual descriptions or speculative artworks, paired with our own realizations. Our decision to stage an exhibit of Cynthia Wey's writings and renderings of her speculative artworks stems from several reasons. Wey provides an example of an artist who practiced her own aesthetic theory, not one beholden to prevalent academic philosophers. She earned no money from her art, and so felt no pressure to conform to trends. She cites contemporary theorists with authority, but does not drop names. Wey also stands as an uncanny harbinger of an apocalypse that never took place. Yet what we find most arresting are the imaginary artworks themselves. Speculative

works for Wey are not merely Fluxus works by another name, ironic descriptions of artworks like those of George Brecht or Yoko Ono or La Monte Young. Nor is speculative art the same as conceptual art, which foregrounds ideas often at the expense of material. Wey never lacked ideas for her artworks, but her ideas presumed skills she knew that she lacked but that others might possess. Wey's speculative works belong to the same species of imagined art as those theoretical art works that populate the pages of Oscar Wilde, Michel Houellebecq, and Jorge Luis Borges. Wey's failure in the real art world seems only to have steeled her resolve in her interior world, where her imagination could accomplish any feat. We therefore intend these realizations of speculative artworks neither as postmodern, nor ironic, nor nostalgic, but rather as manifestations of Wey's ideas that, we hope, would have lived up to her great expectations.

In realizing these works, we have grappled with considerable challenges. It is one thing to study the writings of the typical twenty first century citizen, but it is quite another to think like one. And it is arrogance to dare to create art as people did in Wey's era; our own era's need to represent extends only so far as to reflect the beauty around us, not to comment or critique or negate. These hurdles notwithstanding, we humbly claim success in copying not only individual works, but something of the artistic styles of Wey's era.

"Commentaries on the Apocalypse"

An essay

"Apocalypse" means unveiling. It is a revelation of the greatest import. Most religions and mythologies have used "apocalypse" to mean revelation of the end of the world, so much so that apocalypse today has become synonymous with the end itself: of civilization, humanity, life itself. But "apocalypse" can also mean the literary genre that communicates prophecy of the end of the world. Such commentaries were prevalent in Judaism and early Christianity. A typical apocalypse-commentary quotes scriptural prophesy and adds exegesis.

Although apocalypse-commentaries necessarily contain text, they are often the showplace of great art as well. In Western Christianity, one of the more famous such writings is Beatus of Liebana's "Commentary on the Apocalypse", composed in eighth-century CE Spain. This was a compilation of Biblical prophecy alongside writings of Augustine of Hippo, Ambrose of Milan, Isidore of Seville, and other Christian theologians. The monk Beatus proclaimed that the end of the world would occur around the year 800, and linked the strange visions of St. John in the Book of Revelation to clashes between Muslims and Christians in Cordoba. The Beatus Apocalypse was copied in several editions, many of which feature impossibly vibrant colors and vivid depictions of St. John's hallucinatory predictions.[1] The edition of the Beatus copied for Ferdinand I of Castile and Leon, for instance, renders matter-of-factly many-headed beasts and the woman clothed in the sun.

These are not fantasies. There is no attempt to normalize, to distance through irony. There is no disclaimer that we are speaking only figuratively.

I once heard a Catholic priest joke about his Protestant

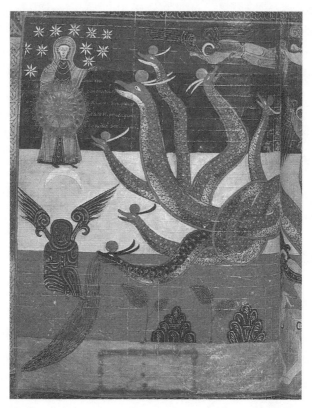

"A Woman Clothed With the Sun", from the Beatus Facundus, "Commentaries on the Apocalypse", f. 186v, for Ferdinand I of Castile and Leon.

friends' conviction that the Rapture was an imminent possibility. He could perhaps believe that any of his socks that disappeared in the dryer had been "raptured" away (his word!), but he gently laughed at any stronger claim that the elect would be spirited away. And of course he felt this way, for many neoliberal Catholics have a hard time with the Book of Revelation. The editors of the New American Bible, the Bible most American Catholics use, have this to say in the Introduction to the Book of Revelation:

This much, however, is certain: symbolic descriptions are not to be taken as literal descriptions, nor is the symbolism meant to be pictured realistically [...] The Book of Revelation cannot be adequately understood except against the historical background that occasioned its writing. Like Daniel and other apocalypses, it was composed as resistance literature to meet a crisis.[2]

The editors here take pains to explain away the Apocalypse in historical and materialist terms – as an expression, a figure of speech. This pragmatism is strange, coming from the same people who believe in the Virgin birth. I prefer art historian Otto Pächt's words on the Book of Revelation and its visual realizations of the Middle Ages:

[...] the author of the Apocalypse, John, like the Hebrew prophets before him who wrote the books of Daniel and Enoch, came from a civilization which was essentially devoid of pictures. The heated fantasies of the Apocalypse as a literary genre paid no attention to what was visually possible. It was apparently this abandonment of restraint in spurning a logical point of view, as if in a waking dream or a brainstorm, which stimulated the Middle Ages – characteristically not the Greek East but the Latin West – to compose in pictorial non-sequiturs. It is all the more important to investigate the imaginative illogicality of this kind of illustration because it repeatedly produced real picture books of a specifically medieval character and some of the most significant art of the Middle Ages.[3]

Implicit in Pächt's statement is the fact that the medieval artists in question believed in the Book of Revelation, not as fantasy or literary device, but as literal truth. Modern Catholic apologetics question the power of this text, as they do the very idea of

apocalypse.

But I have seen the apocalypse. I gradually became aware of it in the course of listening to presentiments of ill-defined dread that overtook me whenever I awakened early, starting sometime in 2006. It's difficult to find words to explain how this dread manifested itself. A gritty, concrete sense that everything I cared about during the day was not only inconsequential, but obscured what is vital. A certainty that death would come soon, and that the state of death would not be that different from that of living. That was only the first stage. A few months later, the visions and auditory illusions began: seeing the walls of my apartment and office crumble on top of me; hearing before feeling the sudden thrust of an earthquake; waking with the words "slip shot" echoing in my brain; imagining the mercury-quick transformation that would occur on the faces of humans everywhere the moment it began. In those eyes, I witnessed the turn away from everyday life with its trivialities to the direness of something we already knew was coming. By February 2007 I had begun to question my sanity. I considered medication, marijuana, suicide. On April 2nd 2007 I awakened with a clear mind and clean heart, for it was suddenly clear what was happening. I put my affairs in order, and bequeathed what few possessions I have. I began to meditate in the mornings and evenings, and made peace with the certainty that the apocalypse, though looming, was still mysterious enough. Its imminence could mean that it could happen in five minutes or ten years. Both lengths of time were the same, which means that time is now irrelevant. I need to be as ready now as I can be, as ready today as I could be tomorrow.

I have asked myself whether I am obligated to announce what I know to those around me. But that would be pointless. The best that could happen would be that I would be taken for some religious nut. And there is the quieter truth at play here, too, that an apocalypse-commentary must be undertaken willingly, without duress, and with commitment. Mass hysteria and peer

pressure are poor justifications for a change of heart. They are no better than being caught in a movie theater when someone yells "Fire!", or when someone opens fire. My charge is to write a commentary not on scriptural predictions, but rather on art that makes oracular pronouncements to anyone able to understand them. There exists an aesthetics of apocalypse. It permeates today's art, and yet has been present in many works as far back as written records have been kept. My apocalypse-commentaries cut through history to sort out the contrivances and doubts and shudders that shake art as it considers the end.

I have tried making art. I am no good at it. This journal is the closest I'll ever get to what I wanted so desperately to do well. But as good as the art I have imagined might be, better still is the drone music that others have made, that speaks so clearly about apocalypse. The end is the moment when words fail, when everything fails, when limits are reached, when the infinite is revealed as real and the finite as ideal.[4] Drone music is an art that can gracefully, almost casually conjure the heat and death and terror and joy that the apocalypse will bring, its torturous moral dead-ends. Read this book, then, as a revival of the apocalypse-commentary. It does not speculate about whether the end is coming, for the end is an imminent and foregone conclusion. It reflects on drone works that I now know to be prophetic declarations of apocalypse. This exegesis assumes the form of essays and speculative artworks, descriptions for art that does not yet exist. This apocalypse-commentary is not a religious work, for apocalypse calls upon religion and agnosticism and atheism with equal verve. No one has the answers. No one is properly equipped, with faith or reason or hopelessness, to face that which cannot be imagined or expressed. Words fall away as does everything else.

"The End of Happiness, The End of the World"

An essay

A good time to listen to Celer's music is early in the morning, around three o'clock. Any later, and road noise would drown it out. In the album *Salvaged Violets*, high- and low-pitched tones seep in, barely perceptible even on headphones.[1] They are produced on synthesizers, processors of various sorts, and acoustic instruments, but their timbre is uniformly fragile. There are no abrupt attacks, and decays are always attenuated. These tones are too isolated to congeal into harmony, they merely align with each other momentarily before washing out with the tide.

The disc player spins, and the laser reads the data. Naturally, this playback is identical to every other. It will be the same tomorrow, and however many tomorrows remain. I could well play this recording every morning, indefinitely, or at least until the electrical grid collapses. It would matter just as much to me if I heard it constantly, from now until the end.

Salvaged Violets might sound like other recent examples of pretty, quiet music. But this impression gives way with repeated listening, especially around the nine-minute mark. The sudden influx of rapidly oscillating drones, colliding as they compete for the same space, proves that this is not just a touristic celebration of beautiful sounds. This is the moment when one's toes clench the precipice shortly before jumping, or the moment immediately preceding the apocalypse. Celer's music, as with so much ambient drone, speaks of the end of time, the end of the world, and all the unresolvable dilemmas that accompany such ends.

Croesus was a Lydian king who believed himself blessed. He sought confirmation from Solon of Athens, the lawmaker revered for his wisdom. Croesus asks Solon, "Who is the happiest of all

men?", whereupon Solon answers with stories of humble men who live to old age in obscurity, or else who die young in their sleep after winning favor from some god. But Croesus wanted Solon to name him the happiest. Solon responds, "[Mark] this: until he is dead, keep the word 'happy' in reserve. Till then, he is not happy, but only lucky."[2] This passage from Herodotus is famous, but what follows is more important. Solon admonishes Croesus to "look to the end", rather than the present. Croesus dismisses Solon, and only later learns the meaning in Solon's words. He loses a son in a hunting accident. He concludes two years of mourning with the decision to attack the Persians, and his oracle responds that he will "destroy a great empire."[3] Croesus is foolish enough to hear a presentiment of the fall of Persia, but the empire to fall is his own.

It would then appear that Croesus is about to reach his own end as the prisoner of the Persian tyrant Cyrus. He is about to be burned alive on a pyre. As the flames char Croesus' hair, Cyrus is moved to spare Croesus, but his men cannot stop the fire's spread. Croesus prays to Apollo for mercy, clouds rush in on what was a perfectly clear sky, and rains put out the fire that was to mark Croesus's final, unhappy ending. Croesus spends the rest of his days as a guest and prisoner in the Persian court, trotted out anytime his captors seek counsel on the behavior of an enemy or the proper course of war. It may well be that Croesus narrowly missed a horrible ending to what had been a blessed life, but strangest of all is his subsequent resurrection, the turnabout that made a king into a valet, a ruler into a sycophant.

Those of us who know what is coming feel great joy. Something miraculous is coming, the liberation from our bodies, but that liberation comes at great cost. Billions of people will suffer. There is no way to justify how we could feel happy, by what right anyone could smile given what we few know. And it's unclear whether what we feel is even happiness at all. How can

it be, if it cannot last? One could rewrite the opening of the *Nicomachean Ethics* with apocalypse in mind:

> Every art and every inquiry, and similarly every action and choice, is thought to aim at some good; and for this reason the good has rightly been declared to be that at which all things aim. But a certain difference is found in the time of apocalypse, when activities can no longer have ends. For naturally, in a time in which ends are irrelevant, when the final end precludes all other ends, the good takes on a different meaning. Where there are actions apart from ends, at least ends that lie in the future, it is the nature of the activities to stand apart from their products. We must thus concern ourselves with what right action and goodness are when the end is at hand. Now, as there have been many actions, arts, and sciences, their ends were also many; the end of economics was wealth, that of bomb-making a bomb, that of plastic manufacturing a plastic bottle. But where such arts meet with a certain end not only of one person, but of the entire civilization or even of the planet, the question of ends becomes moot. It now makes a great difference whether activities themselves are the ends of the actions, or something else apart from the activities, as in the case of the sciences just mentioned.[4]

Aristotle wrote that the ultimate end of human activity is happiness: eudemonia. To attain eudemonia, we weigh present against future satisfaction, balancing virtues against necessities. But Aristotle said that happiness must be measured over a lifetime, that it cannot be reduced to a single moment.[5] Spoken with the confidence of someone assured of a long life. What is the ultimate end in the time of apocalypse? If we accept Aristotle's premise that it remains happiness, then how do we define happiness, and the virtues that inform our quest for happiness,

when the end is imminent?

We delude ourselves that we will live long lives, that our relative happiness will be an average of joy and sorrow and boredom stretched out over the years. Apocalypse exposes this lie. It pushes us to take up Plato's call in the *Gorgias* to stop thinking about how long we have, and instead about how best we might live in whatever time remains.[6] The truth is that the end is coming soon, in a month, perhaps, or a week, or in five years. Eudemonia should be the same whether we live only five minutes more, or five decades more. We see all this, and yet the truth eludes us, for until recently, happiness has meant for us the idea of being happy at some point in the future or past, not the present. In the *Gorgias*, Zeus is said to have instituted a law that no one shall know their death ahead of time. Like that line at the end of *Blade Runner*: "Too bad she won't live. But then again, who does?" This is supposed to be our final tip-off that Deckard, like Rachel, is a replicant, and has no more than three years to live. But what it really tells us is that apocalypse only magnifies mortality, something already there, on a mass scale. Every individual's death is her own apocalypse.

If Aristotle and Solon were right, then a life qualifies as happy only if it lasts a full duration, and ends happily. But if the apocalypse is drawing near, as it must considering our species' efforts to bring it about, then all lives will have been cut short, and we will have died with the knowledge that the end was prematurely upon us. So none of us will be able to claim that we were happy in Aristotle's or Solon's terms. The only hope I have of proving these two Greeks wrong, of leaving evidence that I have known moments of blinding happiness, is to stop time even as it drags me with it. I now look to the end, but while searching for moments of joy that halt time altogether.

The music of Celer intimates what such happiness might feel like.[7] It is achingly beautiful: cascades of electronic tones, or field recordings or snatches of piano or string chords played at low

volumes. Celer is most courageous when it bypasses noise and technical tricks. It sounds like what it is to watch the moon set over the ocean at night, or to see one's beloved enter the room after a long absence. Celer's music is usually constructed with loops that repeat for a half-hour, or perhaps over an hour. Their duration does not matter, for this music has bestowed on me a happiness that no one, not even someone blessed with contented old age, has experienced. Boethius understood the lightness with which we can let go, after having been granted such joy. Writing in house-arrest before his execution, he said that no evil can destroy the memory of happiness.[8] His optimism puts to shame those who are neither imprisoned nor condemned to death, and who are therefore tepid in their joy.

And so the spinning continues. There is the spinning of the disc player, going over the same zeroes and ones that it has read every morning since I began listening to *Salvaged Violets*. There is the spinning beating of the tones, sometimes constant, other times accelerating from dissonance back to consonance. These are toy tops of sound that whirl and gyrate, going so fast while going nowhere at all. Self-contained, they are monads that reflect all these worlds of happiness, each in their own particular way. Take any one of these oscillations, increase its speed to the point where individual revolutions disappear within a perceived uniform total, and what we have is an edifice of eternal happiness, eternal for however long it lasts. So it is with every successive wave of sound in *Salvaged Violets*.

The ethics of apocalypse starts with this, that it should be no different than ethics for those who assume that death will come only in the distant, unspecified future.

Aristotle's definition of happiness requires that we remain virtuous, and virtue means that we "must, so far as we can, make ourselves immortal, and strain every nerve to live in accordance with the best thing in us".[9] But the immortal gods are none other than they who can live an eternity within a single moment, even

if that moment is immediately followed by death. We mortals, however, are divorced from any comprehensive experience of time. We pass from moment to moment, too abject to grasp the unity in infinity; Plato, Aristotle, and Boethius all agreed on this point. But Dostoyevsky knew better than all of them. He realized that one can live a lifetime of happiness within a few moments. He also understood that such moments come at great cost. In *The Idiot*, Prince Myshkin speaks of a prisoner about to be shot before his sentence was commuted. The convict systematically spends his last five minutes, which "seemed to him an infinite time, a vast wealth",[10] taking leave of his comrades, thinking for the last time not in a rushed, delirious fashion, but almost happy, serene, perhaps ecstatic. He stares at the golden cupola of a distant church glittering in the sunshine. And then,

> he said that nothing was so dreadful at that time as the continual thought, "What if I were not to die! What if I could go back to life – what eternity! And it would all be mine! I would turn every minute into an age; I would lose nothing, I would count every minute as it passed, I would not waste one!" He said that this idea turned into such a fury at last that he longed to be shot quickly.[11]

And so it must have been for Dostoyevsky himself, who thought these same thoughts when he was about to be put to death for political conspiracy before being similarly spared. Such an event must have exacerbated his epilepsy. Indeed, Prince Myshkin, who is also epileptic, feels a similar elation in the seconds immediately before a seizure, a flash of light during which "he had time to say to himself clearly and consciously, "Yes, for this moment one might give one's whole life!".[12] The price for that moment is exorbitant: pain, idiocy, total disconnection from all the bliss of the preceding moment, disconnection too from every other human. Myshkin lives an apocalypse of sorts every time he

has a seizure, from which it takes him months to recover. In the intervening time, he must rebuild himself. The cosmic epiphany he experienced is irretrievable, at least until his next seizure.

Celer's music also intimates a dear price. I am thinking now of "Of My Complaisance", from *An Immensity Merely to Save Life*[13]: 18 minutes of a fragment lasting 35 seconds that is looped, with no variation, until the track's close. The fragment consists of a short melody plus harmonic accompaniment played on the strings-setting of a synthesizer. There is ample reverb, and although there is a definite, discernible melody, the texture is smooth, with no percussive breaks or attacks. This melody for the most part outlines a major key, descending at first, until at its low point accompanying strings arrive on a single, held pitch high up in the ether. This is Prokofiev's old trick, to land on low and high notes simultaneously, and just as in Prokofiev's music, the gesture here seems to open a wide space that is beautiful and cavernous, terrifying. The bottom drops out.

Celer's music is always beautiful. I don't like having to rely on that word, but one can't overlook what "beautiful" means in the context of electronic music these days. So much electronica has assimilated ugliness and dissonance. Witness the very genre called "noise", plus distillations of noise elements in glitch, drone, and metal. Celer stands apart by not relying on noise. A few other artists fall into this category: William Basinski, drone artists Capricornus, Kyle Bobby Dunn, and David Tagg, and other ambient drone artists who use either drone-sustained sonorities or loops to create multi-minute or -hour works of unmitigated beauty and consonance.

I mentioned just now the steep price of this music. This price is central to Celer's story, for Celer began as a duo of Will Long and Danielle Baquet-Long, a married couple in their twenties. Their music and track titles, along with their photos taken from worldwide travels, show a grand amour, not merely the happy burgeoning love of youth, but the love that, when it finds its

beloved, says, "Ah yes, I've been waiting for you patiently. We've a lot of living to do, you and I." Danielle Baquet-Long died of an undiagnosed heart condition in 2009, and Will Long today continues Celer as a solo project. Any Celer track sounds like it could go on forever, and perhaps is currently going on forever in some other space. This is music of heaven, how we all might hope the afterlife to be, with no hint of kitsch. A few moments in this music might indeed be fair recompense for a lifetime's worth of disappointment, aggravation, and boredom. But the threat of an abrupt end, of apocalypse, is latent in this music, too.

This sort of happiness confounds Aristotle's theory: we can experience happiness even if we do not have a complete life. We might hope for long, prosperous lives, with our material needs met, and with adequate freedom and opportunity for contemplation. But Aristotle was a scientist, not a mystic. And a mystic is exactly what we need, someone who knows the liberation of which ambient drone speaks. A mystic like Hegel understood that happiness must contain its other, the end of happiness, just as infinity contains the finite. For Hegel, finite things contain "the germ of decease"; they are born at the same time that they die.[14] Celer explains what happiness, our ultimate end, would look like in a time of apocalypse because it reveals that true happiness of any sort is both eternal and susceptible to extinction at any moment.

There is no apocalypse, because apocalypse has always been and will always be with us.

* *

History abounds with tales of military leaders who risk everything for the end of the world, which might lie just over the hill. The Persian king Cyrus was a tactical savant and political prodigy whose arrogance undid everything those qualities had won him. He conquered Greece, Babylon, all of what is now

Turkey, Iraq, and Iran. Not content with those lands, he continued eastward into the land of the Massagetae, the nomadic tribes who lived in what is now Turkmenistan. The first real resistance his forces encountered came in the form of the queen Tomyris. As Herodotus wrote, Cyrus begins his invasion with a marriage proposal, which Tomyris refuses. Cyrus next prepares a military incursion, which prompts the first of Tomyris' prophetic threats: Cyrus must leave, although Tomyris knows he will not. Tomyris then calls for a limited engagement between the two armies in a location of Cyrus' choosing, a means of containing the battle and its ravages. Cyrus accepts these terms, and introduces Tomyris' men to alcohol. Cyrus' army slaughters the drunk Massagetae and captures Tomyris' grown son. She issues her second prophetic threat: release her son and leave her country. "If you refuse," she adds, "I swear by the sun our master to give you more blood than you can drink, for all your gluttony."[15] Cyrus frees Tomyris' son, who promptly kills himself. A battle ensues, one Herodotus claimed is the bloodiest in history. Cyrus is killed, and Tomyris stuffs his decapitated head "into a skin which she had filled with human blood."[16]

Tomyris' roles in this story are multiple, and for that reason, unusual in a text where women seldom receive more than passing mention. She is a desirable female body, a military commander, and a prophetess. She knows that Cyrus will not content himself with what he already possesses, and uses the very image of binging on blood to devise his punishment. And while Cyrus could have heeded Tomyris' warnings, he persists, just as she predicts. His disregard for her prophecy is part of the prophecy.

Subsequent generals have learned nothing from Cyrus. Alexander the Great also invaded the East, driving into Afghanistan and India before his troops forced a westward retreat. Alexander pulled his men back to Babylon before dying of a fever under suspicious circumstances, perhaps due to

poisoning. Several centuries later, the Roman emperor Julian hoped to recreate Alexander's campaign; he was murdered, probably by conspirators from within his army. These men knew what awaited Cyrus and themselves in their search for the eastmost point. So did the Soviets and Americans who, in the name of homeland or oil, pursued their own mad searches for the next mountain or cave that hid whatever enemy propaganda could conjure. Logic and history would have demanded that foreign occupiers halt and embed themselves within land they already controlled. Wealth and territory alone do not compel these invaders. So what drove these commanders to risk and lose everything, including, in the case of Cyrus and Alexander, their very lives?

Thomas Köner's music proffers an answer. Köner creates music from the sounds of the Arctic, an end of the world most of us visit only in our imagination. Köner's materials are spare and consistent: low drones that evoke explosions in cavernous valleys or thunder miles away; shrill metallic screaming; occasional midrange events like a pebble bouncing against a cliff-face or a boot-heel digging into ice; unintelligible radio transmissions. In his album *Novaya Zemlya*, such families of sound congeal into an arrow that points toward an impossibly distant place, an archipelago north of the Russian mainland that scares off almost anyone foolish enough to visit.[17] Köner's pieces pose questions like "what does it mean to go to the furthest point north? How much more remote is it?"And listening to the moment in the first track of *Novaya Zemlya* when the wind enters, a sound that approaches something a choir might sing, makes the place sound almost welcoming. *Novaya Zemlya* suddenly becomes present rather than distant, and it is disarmingly normal, a place where the normal laws of physics apply, where gravity and cold rule together. But the presence at the end of this track collapses into a new absence in the second track, a new fixation on wherever the next geographic extreme might lie. The

colonized territory of the first movement gives rise to a desire to see further, to go further, to find the true end of the earth that Köner so casually unveiled.

Cyrus, awakening early one morning east of the Caspian Sea, must have felt the same way. Though he marched further east than any Greek or Persian before him, he did not discover the end of the world. He merely displaced that limit to some new location beyond the next mountain range. And that only tantalized him to the point of lunacy, such that, twice hearing Tomyris' predictions of disaster, all he could do was to look away toward the east, pretend not to hear or believe, and march off a cliff to oblivion and blood-engorgement. Prophecy should slacken our thirst for the end of the world, to find the end of the world. It does no such thing.

A friend recently returned from a ten day cruise to Alaska. Among his fellow shipmates were several baby boomers who applauded and oohed at the sight of melting glaciers, with apparently no trace of irony. There flickered in their well-meaning faces no awareness that human actions have made the collapse of the Arctic into entertainment. He saw a lake the size of San Diego's Mission Bay, one that a year prior had been a solid glacier. The tour guides said that this sort of cruise would no longer be marketable in a few years given the current rate of melting. The glaciers and fjords would be gone, replaced with oversized puddles. And yet there was still enough of a sense of what used to be there for my friend to fall sadly in love with the place. Where the world's lines of longitude converge into a single pole, the past and future meet. The prophecy of the Arctic has been clear enough for some time, at least for those not intent on denial. And that prophecy addresses humanity just as Tomyris addressed Cyrus, warning him of the future even as it acknowledges the futility of that warning. That end of the world, that geographical extremity, is perhaps where we can foresee the end of the world most clearly.

I will not make it to the Arctic before the end. But I go there late at night by means of Köner's recordings, when the sounds of the outside world have momentarily abated. Köner's work evades not only description, but even the sense that one has even listened to it at all. In the track "Teimo", for instance, waves of low-frequency drones and rumbles wash in and out like the tide, and higher tones occasionally enter.[18] "Permafrost" begins with a bass buzz so low it is better sensed in the gut than the ears. The track accrues volume and power while leaving no musical trace, no melody or progression or instrumental timbre that would render the experience intelligible. Köner knows the Arctic well because he spent some years of his childhood in the region, and can evoke the Arctic's vastness and emptiness better than any other sound artist or composer. Just like Celer, he knows the power of pairing the very low with the very high, but to this he adds the very slow movement of a glacier. (At least they used to be slow. As my friend assures me, they break apart quickly now.) And so the most remarkable thing about Köner's music is the sense that one has not, and cannot, apprehend it in its entirety. So much of it eludes perception by dwelling at the extremes of our acoustic or temporal perception. Change thus manifests only in retrospect, when it suddenly becomes audible that the texture of a track's end is far different from its beginning. Instead, Köner relentlessly posits an elsewhere, an extreme point, something to which we strain to listen and whose position we hope someday to reach. Failing that, for of course we will utterly fail in that campaign, we merely sit back and listen to what sounds like eternity, something unknowable, unfathomable, and unchanging.

"The Big Bang"

A speculative artwork

A single sheet of white paper, 11" x 17", framed and enclosed in plastic, and mounted on the wall. On the paper is typed in old-fashioned typewriter font: "Imagine the loudest sound that has ever occurred. A sound one thousand times louder than that of the Krakatoa explosion. A sound loud enough to burst the eardrums of anyone within a five-hundred-mile radius. This sound is coming." This work is mounted on a wall where nearby speakers play Kyle Bobby Dunn's "Butel" (from the album *A Young Person's Guide to Kyle Bobby Dunn*[1]) in a loop such that the recording restarts once it reaches its end.

(Curators' description):

This is the most literal and easily rendered of Wey's artworks. We prepared the document as described, and play Kyle Bobby Dunn's "Butel" as Wey indicates; there is no reason here to take liberties with what she intended. We instead note the friction between Wey's text concerning a sound that, once heard, will never permit hearing again, and the drone work she indicates as accompaniment, a radiant work that could easily serve as innocuous background music for gallery attendees. Wey's message indicates a gorgon-moment, a threshold that when passed changes the observer forever, an apocalypse of the senses.

"Manifest"

An essay

The melancholy of William Basinski's album *Melancholia* is most insistent at the beginning.[1] Track 1 in a minor mode loops a piano-cello half-cadence emphatically. This figure is sadness incarnate, the cliché that much Western art music has leaned upon to communicate longing and suffering. Track 2 presents a ghost of a major-mode melody, nothing more than an ascending and then descending scalar run buttressed by a few chords. It is less perseverant than Track 1 until one realizes that it too is looped. Track 3 takes this same material from Track 2 but warps it with reverb and decayed-tape sounds. Track 3 thus reiterates a reiteration. Basinski lays out these tracks, undeterred by repetition. What might in conventional circumstances be the epitome of boredom or mania is here the central issue: reiteration. This is not a sad story, or any other type of story. It is a clinical rehearsal of melancholic musical conventions. Melancholy is sadness without reason. Narrative imputes causality; causality is a web of reasons and their causes. So narrative is not the best vehicle for conveying melancholy. A melancholic artwork will take melancholy apart to consider it from different angles and in various lights. Without the demands of narrative and teleology, the melancholic work wallows and feeds its neurosis. Basinski does this in *Melancholia*, a work divided into fourteen tracks. There are some recurring materials: piano and cello, shortwave radio noise, reverb and tape hiss. A few later tracks repeat material from earlier ones. Rather than searching for the causes of melancholy, though, the album slowly eviscerates melancholy. *Melancholia* enacts melancholy by repeating, taking apart, and making lists. Basinski has made a manifest of sadness. And manifests are one of the elements most

intrinsic to apocalyptic art. Manifests are a preparative for the end, and they anatomize their objects of inquiry.

We make lists when melancholy veers out of control, and also when we want to assert control. Book VII of Pliny the Elder's *Natural History* departs from its zoological inventory to recall that Alexander the Great commissioned his teacher Aristotle to tally every animal in the Empire. Aristotle received data from thousands of inhabitants of Asia Minor and Greece, "people who made their living by hunting, catching birds, and fishing, as well as those in charge of warrens, herds, apiaries, fish-ponds, and aviaries."[2] Empire reigns over animals as well as people, and so Alexander's order is logical in its fashion. But Aristotle's aspirations exceeded Alexander's. Alexander wanted only to rule the world, while Aristotle dared to know the world in its entirety. His zoological findings assumed the form of a work Pliny calls "On Animals", presumably what we know today as the treatises *History of Animals*, *Parts of Animals*, and *Movement of Animals*. These texts are manifests listing information drawn from his own animal dissections as well as the accounts from Alexander's subjects.

A manifest is one sort of list, and lists can be either optimistic or pessimistic but never neutral. Inventories track acquisitions and sales. Testaments bequeath possessions to inheritors. Typologies uncover the essential amid the accidental: a series of silos as in the photography of Bernd and Hilla Becher, or the Rouen cathedral at various times of day as in the paintings of Monet. Manifests are lists of passengers, and are among the first resources consulted in the event of a transportation disaster. Lists can result from an expansive impulse to document ownership, akin to the great-hearted bully who loudly buys everyone's drinks, or else the tyrant seeking to inventory conquered lands. Or they can come from a constrictive impulse to capture some portion of everything, before everything vanishes.

Narrative supposedly renders manifests obsolete. Narratives

chart change and growth. They impose causality. Music scholars argue as much for the conceit of motivic development, suggesting that the music of Beethoven, Brahms and Schoenberg treats sounds as plastic materials that retain their identity even as they metamorphose. The stasis of manifests runs counter to narrative and development. Hence the contempt of the chair of the Composition department when his well-meaning student included him in our conversation about Éliane Radigue. That student later apologized for his teacher, mentioning the rancor between the old guard and the minimalists. Drone music for the conservatory crowd is indistinguishable from the music of John Adams or Philip Glass. But the professor didn't know that drone is a form of manifest, and that manifests are more antique than even his beloved classical music. Drone music dwells in one immanence, or iterates similar static utterances. Drone music coaxes what it can out of everything to celebrate or to prepare for disaster. Drone music is an account of what we can acknowledge before the end. Minimalists have said some of this already. But even minimalist ideology is ill-equipped to explain Basinski's drone loops. The music of Adams and Glass is always running, eager to unravel its story. Yet *Melancholia* counts down successive entries that add up to no particular story, just the everything. One time is not enough in listening to Basinski, nor ten, because each iteration approximates the everything that it never realizes.

Basinski creates manifests of melancholic figures, while Celer's music is a manifest of beautiful sounds. It would be fairer still to say that Celer's music is a manifest of beauty. The beautiful is the subject, not an adjective. This beauty arrives first, makes its own campaign before lineage and philosophical allegiance stake their claims. At times, this manifest classifies sounds according to timbre and theme. A good example is *Engaged Touches*, the album whose conceit is travel even though its materials bypass narrative to wallow in static snatches of

consonant chords.[3] Consider the effusive miracle that is the opening of Part I. In this section, one's happiest forgotten dream emerges from oblivion. A chorus of nearby human voices, a harp, some synthesized strings circulate rumors of paradise. Such instances are interspersed with field recordings, a nod to Schaeffer's *Étude à chemin de fer* with their bands of recurring train noise. There is also the grand amour, the simultaneous sinking and ascension that any adolescent falling in love for the first time has suffered. This happens in the last section of Part II of *Engaged Touches*, and it's a moment that is too beautiful to disbelieve. This hope appears also in "Who Feels Like Me, Who Wants Like Me, Who Doubts Any Good Will Come Of This", from the album *Panoramic Dreams Bathed In Seldomness*.[4] Any cynicism falls away in the wake of that title.

Elsewhere, Celer's manifest speaks of faint sounds that pulsate as if illuminated by dying stars. These works speak only at night, when the absence of daylight and outside sounds leaves only the hum of appliances, lights, and the ambition to write that succumbs to the need for sleep. The three 2009 albums *Brittle*, *In Escaping Lakes* and *Salvaged Violets* count as this sort of manifest.[5] I could spend all night with these shards of sound, each unique among its cohort and yet all starting from and returning to nothing. These fragments lack a unifying theme other than the fact that they are fragile and, in their fashion, as melancholic as Basinski's music. They sound string-like as if they were performed on a viola. Yet only something electronic could render this precision, invariance, and despondency. An acoustic instrument would generate vibrato or some other tic of expression; it would try to sugarcoat utter despair. Celer's recordings bestow at once everything and nothing: everything that exists as variety, and nothing that results from such lists. For this pairing, Celer is more forthright than the busybody activity of automatic minimalists like Adams or Glass. The lapping waves of Celer's album *Merkin*, all the same until they are suddenly no

longer the same, do not feign hard work or industriousness.[6]
They admit that one cannot apprehend everything, even with an
infinite number of chances. Manifests overcome the bad infinity
that Hegel diagnosed, the erroneous concept that the infinite is
separate from the finite. Hegel's coup was to show that the
infinite resides in everything, and manifests vouch for this in
disclosing their incompleteness. There is always something
more, something that doesn't let itself be apprehended in the
manifest. This is why the manifest is already complete.

* *

Isidore of Seville completed the *Etymologies* around 630 CE. It
was intended as a manifest of civilization bequeathed to subse-
quent generations, who he feared would lose whatever
civilization persisted amid the ashes of Roman outposts. Isidore
foresaw collapse, and wrote for those who would later try to
rebuild. The book is a dense encyclopedia that offers the origins
of the words it defines. Many of these etymologies are pedantic
or obscure or simply spurious. But Book 16, on stones and
metals, makes up for any flaws:

> Mithridax is a stone from the Euphrates that sparkles with
> various colors when struck by the sun.[7]

The Mithras cult, an antecedent to Christianity, believed in a
savior who came back from the dead.

> Alabastrites is a white stone, tinted here and there with
> various colors. The ointment box spoken of by the Evangelist
> himself was made out of alabastrites (Luke 7:37), for people
> hollow out the stone for ointment vessels because it is said to
> be the best material for preserving ointments unspoiled.[8]

Precious stones not only preserve, but render immortal. And their colors, more perfect than even in a dream: Hyacinth-stone is clear and blue in good weather, but faded in cloudy weather. Galactitis secretes a milky fluid when rubbed, and "obliterates memory". The diamond alone is scorned as an "unsightly stone". Iris, when illuminated by direct sunlight, projects a rainbow on walls. Astrion contains a core resembling a full moon.[9] Isidore documents stones that emit liquids, that change color or vibrancy with the weather, and that perform tasks for their owners. Humans were enslaved and murdered for these stones. Isidore and his brethren would have come across such stones affixed to Gospels, reliquaries, and altars. Their use in religious objects would have drawn scriptural justification from the Book of Revelation, whose apocalyptic vision placed precious stones and gems in eyes, buildings, and clothing. Milton populates Heaven, Hell and Eden with similar substances whose surfeit of color stultifies me.

The miracle in the *Etymologies* is the isolated, beautiful stone. When we sift through memories at the end of life, what else do we do, after all, than hold up pictures one after another, to admire their colors? The story relating these moments into a cohesive narrative falls away. There were times of happiness. A view of an island, a whispered conversation at the heart of a labyrinth. Reading a text that reminded me that I was not alone. A chord or melody, held only for a few seconds, replayed to imitate infinity. Everything that shone, that burned, that wept, and then was nothing.

In his manifest of the peoples of Africa, Herodotus describes the Atarantes, who dwell on the edge of the known world. Herodotus does not try to understand or explain them. He cites a few of their qualities: they possess no individual names, and curse the sun. Ten days out from the Atarantes are the even obscurer Atlantes, whose description ranks among the most minimal and ravishing passages in a book fairly teeming with

them. "They are said to eat no living creature, and never to dream."[10] Though Herodotus moves on in the next paragraph to another place in Africa, the Atlantes section poses questions not easily shaken off: Is it good never to dream? How do the Atlanteans survive if they eat no living thing? And of their neighbors, the Atarantes: must we have names, or might we forego them? Could I also curse the sun?

Herodotus elsewhere describes the city of Sardis, impregnable only after its king would carry around his son, a lion born from a concubine, to all of the fortifications. The king undertakes this task but misses the highest precipice, an Achilles' heel of the city where invaders will breach the walls. Although the fall of Sardis is central, it is the passing mention of the king's son that is riveting, for he is literally a monster whose salubrious effects on the ramparts are never explained. Herodotus is credited with writing one of the earliest histories. And "history" here entails a series of events linked causally: a narrative, a story composed of facts. Herodotus' work would seem to adhere to this definition. The sagas of Croesus, Cyrus, Darius, and Xerxes follow each tyrant's empire from rise to ignominious fall. But the best moments in Herodotus, the points of mithridaxian light, are the digressions and incidental ephemera that halt the narrative. These moments, like those in which the Atlanteans or the Sardis lion confound reason, are shards of light that shine for no reason. They are proof that Herodotus' work is a manifest of the incomprehensibly beautiful.

* *

Anatomical art is another type of manifest. Paul Virilio argues that the twentieth century is responsible for anatomical art in his essay, "A Pitiless Art." World wars and concentration camps, eugenics and teratology find counterparts in art that subjects the body to deprivation and humiliation:

expressionism

futurism

actionism

sampladelia

noise music

Dada

Art Brut

torture porn

These all aestheticize barbarism. For Virilio, pitiless art makes us hungry for immediacy, presence, liveness, even as it refuses tolerance. "To suffer with or to sympathize with? That is a question that concerns both ethics and aesthetics…".[11] Virilio locates pitiless art in the early 1900s, but traces its lineage to some anatomists of the eighteenth and nineteenth centuries, doctors who believed that pity impedes scientific observation. But these examples attribute novelty to a quality that predates the modern era considerably. Sebald, for example, writes of Rembrandt's "Anatomy Lesson", a depiction of an executed thief undergoing public autopsy. The size and position of the flayed left arm are, for Sebald, intentional errors, a "crass representation" that "signifies the violence that has been done to" the thief.[12] Rembrandt's pity for the thief drove the painter to expose the callousness of the doctor and his students.

The lack of empathy Virilio decries is only the terminal stage of a far older impulse. At what point does barbarism begin and empathy end? Some might say when wealth and power beckon, but I feel that barbarism can also emerge when the mind sets out to know everything, when it fancies itself capable of knowing everything. The subtlest savagery begins with the project of listing all the world's attributes, of documenting truth, of establishing systems out of entropy. Aristotle's *History of Animals* is a vast description, a manifest of differences amid shared characteristics. Antennae and nails and tails and teeth, organs, snouts,

reproductive glands: they accumulate until no animal is a whole, but rather a composite of parts. Some animals have claws, others hooves. Aristotle occasionally sounds like a poet: "Many animals have memory, and are capable of instruction; but no other creature except man can recall the past at will."[13] Aside from its landslide of raw knowledge that provides transient joys, the treatise gives no sense of philosophical purpose. It is a catalog, a list, a bulk dump. Not so with its counterpart, *Parts of Animals*, which categorizes body parts. It documents phenomena, their causes and their usefulness, or as Aristotle puts it, demonstration and necessity. Formal design is not enough. We must study the reasons behind form, even when confronting talking, severed heads, or wounded men who laugh uncontrollably. Stomachs, gall bladders, viscera, muscle, bones, tendons: all receive their explanation thanks to the raw data of autopsy, biopsy, and dissection.

Robert Burton's *The Anatomy of Melancholy* claims mastery of depression. It is a manifest of causes, symptoms, and cures. Burton quotes from antique, medieval, and contemporary texts, and it is exhilarating to run with him through his library. Although he may have traveled only as far as London, Burton left no continent unexamined, no people unconsidered, no sadness uninvestigated. Not empirical research, admittedly, but Burton's is nonetheless the most rigorous of speculative ventures, a gambit to map the whole of melancholy by means of the mind alone. I write about it, Burton confesses, to alleviate my suffering from it. In fact one Robert Burton (though we do not know if he was the author or only shared his name) did in fact seek treatment from a London physician. We know from Burton's admission that his treatise was his therapy. He charts, categorizes and systematizes, feeble attempts to contain the manifest that overwhelms him and us all.

Aristotle's animal tracts are also full of encyclopedic detail, although they lack Burton's single-minded focus and frenetic

desire to assuage that of which he speaks. One would be hard-pressed to discern any goal in Aristotle's writings aside from satisfying his own curiosity, or at least attending to the multiplicity of the world. Aristotle sees the universe as a beautiful, intelligible mess, a library requiring only time and study before it will reveal its secrets. Yet Christopher Long suggests that Aristotle perceives a remainder, something in all creation that lingers after words and reason have anatomized what they could.[14] His method was the empirical counterpart to Burton's speculative anatomization of melancholy.

Burton quotes nearly verbatim Hippocrates's description of Democritus in Abdera. Townsfolk beg Hippocrates to do his best with the madman Democritus, who is "in his garden in the suburbs all alone, 'sitting upon a stone under a plane tree, without hose or shoes, with a book on his knees, cutting up several beasts and busy at his study.' [...] Hippocrates demanded what he was doing: he told him that he was 'busy in cutting up several beasts, to find out the cause of madness and melancholy.'"[15] Hippocrates congratulates Democritus on his happiness and leisure. Democritus asks Hippocrates why he does not enjoy that same leisure. Hippocrates answers that the responsibilities of life, domestic affairs, preoccupy him. Democritus laughs and the townspeople weep, decrying his madness. Democritus ridicules human vanity; Hippocrates tries to defend humanity, saying that we do the best we can in ignorance of our final fates. Finally, Hippocrates leaves Abdera, telling its inhabitants that there is no wiser or saner man than Democritus.

Burton calls himself Democritus Junior, and explains his book as its own dissection of melancholy and madness. He is a materialist because of his faith in alchemical and herbal and pharmacological remedies. He is a materialist also because his book treats the contents of his mind's library, the books he has read, with promiscuity. Ideas and texts are just more things to acquire. The greedy mind always covets new knowledge to fill the

nothingness, and the everything seems so attainable.

Basinski's *Melancholia* doggedly returns to its few motives, fragments repeated beyond the point of mania. It holds aloft a cliché, a piano and cello oscillating between a minor tonic and its dominant, and returns to it, examining it from different angles, then removing it altogether to reveal the acoustic resonance it has left behind, as an anatomist removing an organ to reveal the soft tissue beneath. Anatomical art is cold, but coldness is perhaps the only fitting response after the heart has burned and bled and then stopped.

* *

A cleric in seventh century Spain, Braulio, wrote this testimonial about his friend, Isidore of Seville:

> After such misfortune in Spain in recent years God encouraged him, as if he were setting up a prop — to preserve the ancient monuments, I believe, lest we decay into rusticity.[16]

Braulio then quotes from Cicero's *Academica Posteriora*, which itself commends the writer Marcus Varro:

> Your books have brought us back, as if to our home, when we were roving and wandering in our own cities like strangers, so that we might sometimes be able to understand who and where we are.[17]

The tears Braulio choked back as he wrote this could have been for sadness at the loss of his friend, or else relief, or gratitude. The Iberian Peninsula had been wracked by continuous war and invasion since the death of Imperial Rome. Some newcomers embraced civility and literacy, some even converted to

Christianity, but many burned and tore down. History, the sense of cultural continuity, books and libraries: none of these phenomena enjoyed anything other than precarious existence. Isidore's *Etymologies* took stock of civilization so that those who followed would know their legacy. His manifest was the greatest inheritance, indicating what survivors could claim in order to repudiate barbarism. A modern reader might discount manifests. But art and culture thrive with stability. When the world is poised to end at any moment, manifests become indispensable. They prove that we were ever here.

Writing is an exercise in holding off death. Shopping lists compensate for memory lapses. Diaries catch thoughts that will slide into oblivion. I write this manifest, a list of lists, because we will all die, as will all civilization. And so while my action stems from the bleakest knowledge, it is also a hopeful gesture. I wager that someone will come later who will be able to and want to read this. There is a melancholy in these manifests that results when the desire to document collides with the impossibility of documenting everything. The impulse to make lists and manifests is no less strong in contemporary art than it was in antiquity or the Middle Ages. We could turn to the photography of Bernd and Hilla Becher, German photographers who documented industrial monuments like silos and warehouses just as they were about to be torn down in the 1950s.[18] The Bechers frequently worked with typologies, series of images of the same type of object, in order to capture the essential amid varied manifestations. This is no longer just the apocalyptic duty of taking account of everything before it disappears. There is the added despair of technology that supposedly facilitates archiving, yet that only obscures the documentarian's task. Celer's music makes sense not when discussed in terms of its resemblance to minimalism or drone, but rather in terms of its complicity with manifests past and present, manifests constructed with words and images. Celer's "Arenaria" from

Butterflies (itself an album whose five track titles catalog species of butterflies) burns for forty minutes on one chord, each note of which fluctuates at its own rate. It could be regarded as utterly boring music, or else as compelling art for its fidelity to the incandescence of the present.[19] "Arenaria" is always changing within the strict terms of its existence. It does not repeat, nor is it static, but it reiterates. And no matter how much it circles around the same sounds, those sounds always evade capture.

Andreas Gursky and Edward Burtynsky are two contemporary proponents of the ungraspable in manifests. Many of Gursky's photographs take up typologies in the style of the Bechers, but they show multiple types of the same subject within one single photograph.[20] His wide-angle shots of stock exchanges, for instance, show much and so little. There are hundreds of identically-dressed (in white shirts, red vests, and black ties) traders at their computers. Modularity and reiteration are endemic to the system. And what a system: an ecosystem of drooping shoulders, slouching backs, deflated faces, and vacant eyes. If together these lost souls, their equipment and the room in which they toil comprise a Baroque, ornate, perfect composition, then each cubicle on its own is a testament to entropy and the death of hope. Most devastating is "Hong Kong, Shanghai bank" (1994), a nighttime shot of a skyscraper with floor upon floor of cluttered desks, computers, and employees. There is just enough detail to make clear that there is not sufficient detail. We surely know that each person in this photo is his own, has his own weaknesses, thwarted wishes, and personality. We notice all of this, yet it is not apparent in the photo, which locks us out of intimacy, narrative, and differentiation. These are lists of the casualties of our time.

Paging through Gursky's collected work gives the impression of a slow-panning camera as it surveys every possible subset or iteration of its subjects. Not coincidentally, such a slow-panning shot constitutes the opening scene in a documentary on

Burtynsky's photography, *Manufactured Landscapes* (2006), a single tracking shot lasting eight minutes.[21] This opening sequence is set in a large Chinese factory containing aisle after aisle of uniformed employees at their machines. There is no introductory statement of what this factory produces, but we can see that it involves plastics. The shot's rhythm is dictated by the aisles. Each aisle stands apart from its counterparts on the basis of its employees, who are women either seated or standing, hair loose or tied back under a rag, or else men slumping over their machines. Strangest are the instances when a worker peers directly into the camera. His look is non-committal, for the head and neck are the only parts of his body that turn to look. His shoulders and torso and legs remain at their station, loath to attract a supervisor's reproach, afraid to stop working even for a moment. Our eyes want the camera to linger on these faces. For their eyes betray hours of reiterated movement, systematic administration, team culture, and the legion ways in which this factory and human acquisitiveness have relieved these workers of their dreams. But like these workers, the camera must not stop. Its slow transit continues unperturbed at the speed of perhaps a foot every second or two. The factory is this long. The camera's only concession to these melancholic eyes is its pivoting on its axis. Instead of facing obliquely leftward in the direction of its transit, the camera occasionally veers to the right to gaze just a bit longer on an employee, or at least that's the reason I attribute to it, for nothing else in the frame expresses desire, subjectivity, or anguish. But the pivot is soon corrected, and the camera continues its steady slide through the brightly lit dungeons that fashion our laptops and phones and soon-to-be junk.

"Photojournalism of the Fall"

A speculative artwork

I want to see photojournalism of apocalypse: camera-images of moments of falling and calamity. Like the photos that blanketed newspapers when I was growing up, these would feign naturalness, as if taken by an unseen observer. And like those photos, these would nonetheless be patently staged, with just the right lighting and composition and subjects. I envision a room devoted to historically significant moments of collapse, such as the moment when barbarians enter Rome (although weren't there many such instances? Why privilege one?), or when the Greeks finally breached the walls of Troy. Falls like these count as apocalypse for those who had an interest in maintaining institutions, metaphysics, or hierarchies.

1) Barbarians at the Gate

The first photograph captures the invaders entering Rome. In modern thought, this is a very specific moment, when the grandeur of the empire finally gave way to barbarism. Of course, moderns have no idea what they're thinking. Rome was invaded at several points, but the invaders weren't nearly as destructive as fire, lead plumbing, or endless military campaigns.

A single shot from below shows the upturned eyes of a barbarian woman who is raising her first in the air. She is caught in mid-sentence, perhaps shouting to comrades. A rampart, smoke, some chaos in the background. Her eyes are shining. I am reminded of the beautiful last pages of Gore Vidal's novel *Julian*:

> I am alone in my study. I have already put away Julian's papers. The thing is finished. The world Julian wanted to

preserve and restore is gone…but I shall not write 'forever', for who can know the future? Meanwhile, the barbarians are at the gate. Yet when they breach the wall, they will find nothing of value to seize, only empty relics. The spirit of what we were has fled. So be it. I have been reading Plotinus all evening. He has the power to soothe me; and I find his sadness curiously comforting. Even when he writes: 'Life here with the things of earth is a sinking, a defeat, a failing of the wing.' The wing has indeed failed. One sinks. Defeat is certain. Even as I write these lines, the lamp wick sputters to an end, and the pool of light in which I sit contracts. Soon the room will be dark.[1]

Like many Americans, I have succumbed to the temptation to regard our society, the United States or neoliberal states throughout the world, as the modern Roman Empire. Vidal's writing here is especially poignant for those of us who would like to regard our sprawl and pollution and overpopulation and credit-debt as imperial problems. We are the center of our universe, and thus even our catastrophes command center-stage.

[Curators' description for realization of "Barbarians at the Gate";

"Barbarians at the Gate"(photo by Sean Griffin)

The barbarian woman's eyes here have taken on sunglasses that reflect the monotony of a military cemetery. The ramparts have become a skeletal frame of a structure, a house once perhaps, which a man in a bathrobe uses as a closet. A different manifestation of the barbarian woman looks dreamily at us. And a 1950s-era car signals to a past that can no longer be the future.

2) The fall of Troy

Children's mythology collections depict Cassandra as vengeful, spiteful, even happy that doom befell Troy, that the city that disbelieved her would suffer such humiliation. But I know otherwise. Cassandra in my photograph is neither stricken nor smug. She is looking elsewhere, above the flames and corpses skewered on pikes, to stars only she can see. The eyes of the Trojans now look on her with condemnation. They have forgotten that they had laughed at her. They now blame her for this disaster.

[Curators' description for the fall of Troy;

We have assembled two photo collages: in the first, Cassandra (or Cynthia Wey herself) looks upwards and to the side, her eyes focused on a future invisible to all others. The eyes of her compatriots look blankly through her. They are dead eyes, already collapsed and piled upon one

"Cassandra"
(photo by Sean Griffin)

another. In the second photo, we see an aerial view of a southern Californian neighborhood like the one in which Wey grew up, with each house bordering its own swimming pool. Atop the Spanish-tiled opulence, we see two Bosch-like etchings as well as a freakish animal skull. The caption below it reads "God is preparing".

"God Is Preparing"
(photo by Sean Griffin)

3) Lucifer's fall

Lucifer's fall was an apocalypse for him, a revelation that his pride was exceeded by the pride of his creator. Milton so beautifully covered this moment (it was already backstory in *Paradise Lost*) that there is no point at trying to convey its horror. I wonder, instead, at what Lucifer's legions must have thought, those who followed him with such blind trust. Perhaps they were at first confused, and thought that Lucifer's upside-down body indicated a new gravitational orientation. Up becomes down, wrong becomes right. Pseudo-Dionysius' text *The Divine Names* springs from early Christianity, from the belief that we cannot know God, or at most can know him only through what He is not:

And there we shall be, our minds away from passion and from earth, and we shall have a conceptual gift of light from him

and somehow, in a way we cannot know, we shall be united with him and, our understanding carried away, blessedly happy, we shall be struck by his blazing light.[2]

It is heresy for me to suggest that Lucifer's brethren might have expressed their faith in a similar fashion, by insisting only on what they did not know. But Lucifer's world was an inverted one, an obscene perversion where humans were to be punished for replacing angels as their creator's favorites.

[Curators' description for the fall of Lucifer;

"Preposterous" (photo by Sean Griffin)

Upside-down, inversion, perversion, obscenity: this passage references poles, axes and hierarchies of nature. The first photo, "Preposterous", shows posteriors, bodies twisted unnaturally, and an aerial view of fire upon water, perhaps the most unnatural act of all. The second photo, "Michael", shows a city upside down, its traffic and streetlights a hell. The only attempts to right this wrong, to provide false comfort, are in the right-side-up images of a toddler, a sinisterly smiling businessman, a

"Michael" (photo by Sean Griffin)

woman looking askance to the side, and Archangel Michael, looking down perhaps at Lucifer. To Wey's citation of Pseudo-Dionysius we add another, a better encapsulation of the apophatic theology that she imagines for the dark legions:

> It is at a total remove from every condition, movement, life, imagination, conjecture, name, discourse, thought, conception, being, rest, dwelling, unity, limit, infinity, the totality of existence.[3]

The rebellion was a negation of God's law, but substituted its own hierarchy, just the opposite of the celestial one. Wey's fantasy here resonates with her essay "Radigue's Wager", which demonstrates how cynicism maintains the status quo.

"Radigue's Wager"

An essay

I have listened to Daniel Lopatin's "Nobody Here", to Boards of Canada's "Reach for the Dead", to Leyland Kirby's "Tonight Is The Last Night of the World". They all know what I know. They have heard the future through electronica, and it is bleak. They've heard the rumblings and wavelengths that anticipate doom. These tracks conjure depopulated planets, old recordings played on malfunctioning equipment, forgotten memories of childhood that resurface one last time. All this music is nostalgic for something long gone. These pangs have become just one more gesture; as beautiful as they are individually, as a whole they risk becoming meaningless. But once we sift through today's artists, nearly all of whom would name Éliane Radigue as an inspiration, we are confounded in any attempt at making sense of her own music. Radigue embraces no nostalgia. She avoids sentimentality assiduously. Yet her synthesizer drones are not cynical either. They do not try to shock or break idols. Radigue's music is ascetic without bragging that it is ascetic. Others weep for the end of the world, or shake their fists in rage at the deposed gods, but Radigue stares at the end unflinchingly. She does not try to scare us, or make us cry. She is too busy looking into the void.

"With no more than eight days to live, who would not find that the best bet is to believe...?"[1] So reads Blaise Pascal's famous wager, the jewel of his *Pensées*. Pascal's logic is unimpeachable: if there are only two possible outcomes after death, immortality or nothingness, and if as Scripture states only those who believe in Jesus may attain everlasting life, then the only rational choice would be to believe. One loses nothing through belief. But if Scripture is true, one stands to gain the most important prize of all. I have often asked myself Pascal's question in the days since I

came to learn what will happen, and I inevitably hear in Radigue's music the only sincere response I can muster. After a lifetime of casual agnosticism, why should I not believe in something that would imbue life with meaning? What do I have to lose? And what does Radigue gamble in her music?

It is a commonplace to regard belief as admirable. This, despite not only science's demonstration that empirical data trumps speculation, but the images and ashes of what is left when belief crushes reason and difference and doubt. Like Marcel Ophüls in *The Sorrow and the Pity*, we could ride along with cameras trained on the burned-out buildings of Germany in 1945, and see the cavernous faces of those who accidentally survived, who spent their days sending others to their deaths, or who merely clung to life from bombing raid to bombing raid. Behold the wages of belief. We could contemplate nuclear shadows and corpses turned into charcoal in 1945 Japan. We could turn toward Korea and Vietnam in the 1950s and 1960s, when American imperialism inculcated belief in imminent Communist expansion. Or we could seek out the trifling beliefs that lead an individual to regard someone of another faith or caste or persuasion or gender as punishably astray. Belief is responsible for the apocalypses of the twentieth century. Belief may also be responsible for the impending apocalypse, if that apocalypse ends up being caused by environmental malfeasance. Belief in the superiority of the Aryan race or the God-given right of the Japanese to expand their empire harnessed those nations' energies. The invincible beliefs on the part of today's industries and governments, that global warming is not attributable to human activity or that its effects do not warrant changing our consumption patterns, have set us marching toward a cliff. Such a precipice terrifies us so much that we turn toward still other beliefs, in angry gods who punish those whose politics clash with our own. The more bizarre and hopeless our future, the more we want to believe that nothing bad will happen, or that

our god will rescue the innocent. Belief instills confidence that the world normally abides by rules. Adherence to those rules will heap rewards on the believer, usually after a vindictive struggle with non-believers. Belief always drags along with it the word "should".

But apocalypse need not impose belief. It presents an opportunity to cleanse our eyes of the veils that obscure the truth. If we choose to read it for what it shouts at us, apocalypse reveals the truth that there is no vindication after our suffering, no happy ending to save us. Just emptiness. No deus ex machina, no meaning or sense, just the void. And not a bad void, some existential void that is really despair that things are not otherwise. Just emptiness.

Post-1945 aesthetics exhibits a Stockholm-syndrome-like relationship with belief. This relationship assumes the guise of cynicism, the crutch of contemporary art. It began innocently enough as humor: "Ceci n'est pas une pipe", "L.H.O.O.Q.", even 4'33". Professors take great pains to explain these works as witty jokes. So: Magritte's title and painting decouple signifier from signified; Duchamp with his mustached Mona Lisa repudiates museums, galleries, and aestheticism; Cage recuperates non-musical sound and exposes the prejudices of Western art music. These explanations translate the particulars of the joke, but what is left unstated, what is fundamental to cynicism, is the "should" of belief. The world should be other than how it is; God or social justice tell us what we should do. There is no space for emptiness in cynical art.

Cynicism might seem the only humane response to Holocaust and incendiary bombs and comfort women and biological warfare, all sins stuck like barnacles on the underside of progress and industrialization. The blind pursuit of beauty was another such parasite; beautiful objects and stories and melodies were intended to offset or else cover up the dirtier aspects of Enlightenment. Adorno condemns poetry after Auschwitz as

barbarism[2], and maintains that the only way to remain faithful to beauty in art is to reject beauty.[3] Art for Adorno must exist as a photonegative of aestheticism, acknowledging the absence of beauty in an act of mourning. But Adorno's insistence spells out a sort of aesthetic metaphysics, that art should have to do with creating and interpreting beauty, because beauty reflects the underlying order and hierarchy of the universe. The after-image of beauty, however maligned in the present era, proves the existence of God. But the horrors of the twentieth century of course did not stop in 1945, and subsequent artists went much further than a simple rejection of beauty. Art for Adorno illuminated emptiness, but cynical art pretends to celebrate emptiness.

Houellebecq is known for novels that cast a jaundiced eye on contemporary culture, but he is also a perceptive observer of art. The character of Vincent, an artist and eventually a cult leader in *La possibilité d'une île*, explains in a monologue worthy of a university art history course that there are three tendencies in recent art: gore, irony, and fantasy. Gore is self-explanatory: art that revels in suffering and blood. Irony means kitsch that signals "a metanarration that [we] aren't duped by it."[4] Fantasy art is in comparison utterly lacking in self-awareness, contenting itself with swords, unicorns, and rainbows. The visual artist Chad Attie exhibited his *Contempt* show at the Klowden Mann gallery in Culver City in the fall of 2013, and his cynicism was gilded with an innocence precariously close to fantasy.[5] Attie named the show after Godard's film *Le Mépris*, itself a gloss on Homer's *Odyssey*. The images are mixed-media assemblages of painting, collage, and three-dimensional objects. We see old-fashioned oil-based seascapes with occasional holes cut into the canvas; these holes are filled with black-and-white photos of etchings of sailboats careening in the painting's waves, or color boudoir photos of topless women languishing in bed. My favorite work of the collection is a photographic reproduction of a color sketch of a galleon, in front of which is placed a porcelain

figurine of a young woman in a pink ballroom gown. Her back is turned to us as she gazes at the ship. Attie's title informs us that she is Camille, the character played by Brigitte Bardot in *Le Mépris*, and she is pummeled by disillusionment as her dreams of romantic love with her husband Paul run up against the reality of marriage doldrums. Camille begins *Le Mépris* by doubting her belief in love; by the end, she has given up on her belief as she agrees to run off with philanderer Jack Palance. The contempt in Attie's work is for all outmoded romanticism, all dreams we supposed would come true after due diligence and faith. And yet...Attie himself (and we with him) are also caught in the sentimentality, wishing that life were as beautiful as we imagine it to be.

The repugnance of Houellebecq's categories of gore and irony, both variants of cynicism, might distract from the fact that underneath this cynicism lies sore disappointment that the world is the way it is. Viennese Actionist art like Hermann Nitsch's *Orgien Mysterien Theater* was, after all, staged as bloody ritual, an anti-mass that destroyed the body rather than exalting it in communion with Christ. Broodthaers' intellectual games are an admission that there is no longer anyone at the helm directing aesthetics. It takes jaded humor to hide what is in essence a melancholic complaint: things are no longer what they used to be, what they should be. Morton describes this sort of cynic as a Hegelian "beautiful soul" who is sorely disappointed at the injustice of the world, yet who "[mocks] anyone who dares to actually do something".[6] In the face of that brokenheartedness, some art purports coolness. Houellebecq's third category of kitsch draws from the same impulse, but seeks to re-enchant the broken world. Cynicism and kitsch therefore are only two sides of the same coin.

The world should be a particular way, but it isn't. This statement is the root of desire: I want because I am not yet complete. Cynical art is an urbane reaction to the human

condition, that we desire because we are not already content. Noise and extreme volume and dissonance are rebellions against the conventions that used to guide musical aesthetics, and like any rebellion, these phenomena are calculated to scandalize the old guard. Rebels care desperately what those in charge think. By inciting outrage, rebellion reasserts the jurisdiction of harmony and beauty, for outrage would not occur if beauty were not still dear. My Bloody Valentine's hazy surfeit of feedback only half-hides vocal melodies that are tonal and unambiguously beautiful. The same demimonde that the Velvet Underground celebrates in "Pale Blue Eyes" is the one that writhes in pain in "Heroin". Iggy Pop was punk rock's prophet, and punk is pure cynicism, an aggressive trashing of all aesthetic and cultural icons. Yet no one who listens to his "Tonight" can doubt Iggy's belief in traditional beauty and innocence; a song about a lover who overdoses, it is an anthem to how perfect everything is all the time, and especially at the time of death. Cynical art exists in a dialectical relationship with belief. Belief maintains the positive values upheld by god or government or culture, and cynicism rejects those values for effect. Our punks and avant-gardists are among our sincerest aesthetes.

I hear in recent drone music intimations of the apocalypse, and among these, artists like Celer embrace beauty with the upmost sincerity. Others like Tim Hecker or Basinski walk a fine line between beauty and cynicism, the latter through destroying or deconstructing their sonic materials in a way that, Adorno might claim, maintains fidelity to beauty through rejecting beauty. But Radigue's music is inscrutable. What is her gambit? We can find no recognizable traces of cynicism, no dark or sadistic twists that might suggest complicity with the end. If recent art's cynicism is veiled despair with the emptiness, Radigue's music faces the emptiness head-on.

No one desires the void. It is not a cheery place, and pretending otherwise would be another form of cynicism. The

void depletes anyone foolish enough to direct emotion toward it. The only sane response to the void is emptiness in kind, acknowledging the emptiness rather than avoiding it. This aptitude has been within our grasp at least as far back as written culture. Consider Democritus, who states that only two types of things exist: substances, and the "empty", "nothing", or "limitless".[7] This emptiness is the "non-existent", yet it nonetheless impels Democritus to characterize it as an entity, a present absence. Then there are the passages from the Icelandic *Edda* that describe the nothingness at the birth of the universe: "It was at the beginning of time, when nothing was; sand was not nor sea, nor cool waves. Earth did not exist, nor even on high. The mighty gap was, but no growth." The gap *was*, an equivocation worthy of Plato's *Parmenides*, for the gap exists simultaneously as a thing and the absence of a thing. The *Edda* says that this nothingness persists into the present, and will be there upon the collapse of the universe: "There is one called Surt that is stationed there at the frontier to defend the land. He has a flaming sword and at the end of the world he will go and wage war and defeat all the gods and burn the whole world with fire."[8] Such was the Northerners' sober regard for the void. They did not feign ignorance of what was in store.

Pascal too knew of the emptiness. He was terrified by it: "The eternal silence of these infinite spaces fills me with dread."[9] And so he sought to fill it with the certainty of belief, solace that the afterlife would be filled with meaning absent in the present. Even the suggestion that life could be followed by godless permanent death terrified Pascal into making his wager, a grossly cynical gesture that proposes belief as a contingency plan. Pascal's faith allowed him to drown out the yawning silence. But Radigue's music seeks out emptiness, not to fill it with chatter or rail against its injustice. Radigue's music is the sound of the void, the emptiness that resounds. Take her leviathan work *Adnos I-III* (1973-1980), a sprawling aquifer of drone lasting over three hours

that sets into motion several periodically occurring events: throbbing tones, beating frequencies, and episodic pings.[10] The instrument of this recording, the ARP synthesizer, contains a warmth and depth like raindrops dripping into flower pots and steel drums. Any description of a Radigue work will walk up to the edge where words may go no further. A listener either jumps off the cliff, throwing herself into the wash of sound that shuns any credible justification, or she backs off, perhaps regretting the time she wasted flirting with such sparseness. Throwing oneself into that void might seem like an act of faith, but it is the contrary: a sober gesture predicated on the certainty that there is nothing to be revealed or gained in Radigue's music. At the end of its monumental proportions, it simply stops. The only comfort to be had from such an experience is that Radigue, and we for listening to Radigue, did not succumb to the temptation to fill this void with virtuosic writing, or technical displays of compositional craft. No one screamed obscenities into a microphone, and no one railed against the injustice of beauty in the present era. Nothing sanctified *Adnos* with meaning. Voids have no meaning.

Parmenides' poem warns of the distinction between the way of truth and the way of opinion.[11] We can choose to believe what others accept as established fact, or we can dedicate ourselves to finding the truth. It is a brave poem, but a frustratingly incomplete one, and we cannot know how Parmenides envisioned the path to truth. Was he an empiricist? Or did he mean that speculation was enough to access truth? Parmenides' wisdom could be foisted to most any polemic, so much so that it may seem dangerously close to banality. But the one belief that underlies so much human activity and thought may nonetheless be well-suited to Parmenides' dichotomy. That belief is that belief itself is important and necessary to fill the emptiness. The impending apocalypse drags the emptiness into center-stage. We can successfully avoid it most of the time, indulging in the all-too-

convenient belief that we will live forever or die in our sleep when we are old and content. *Adnos II* begins not where *Adnos I* left off, but abruptly, with frenetic energy that the first portion lacked. The agitation of its first five minutes eventually coagulates into a solid chord rather than one rocked by undulations, but its insistence shakes anyone from a lull that might have accrued as *Adnos I* matured from laconicism to innocuous boredom. There is no time left to hide from the emptiness. *Adnos II* does not allow us to turn its sustained tones into wallpaper, nor does it make its tones into effigies of beauty. It is present music, not uncomfortable or painful or sacrilegious.

* *

La possibilité d'une île is as grim as any apocalyptic artwork. But Vincent's own art is the rare apocalyptic art that is utopian and tremulously hopeful. His first success is a Beuys-inspired video work that displays the words "Feed the people; organize them." A subsequent work is a light installation depicting idyllic mountains, stately citizens dressed in Victorian-era garb, and a wedding celebration. The work abstracts the happiest clichés of human society: celebrations, courtship, vacation, even slogans like "Lighting is a metaphysic" and "The best of the world."[12] It's tempting to ascribe a cynical undercurrent to the work, but Vincent lacks any hint of cynicism. He is intelligent rather than naïve, and unstintingly sincere. His works forego any melancholic admission of the impossibility of their representations. Though what Vincent portrays may be a fantasy, it is a fantasy he believes is possible, even inevitable. This future might require an apocalypse, but the aftermath will make us forget every pain that afflicted us.

There are moments of epiphany like Vincent's in Radigue's music. The work *Jetsun Mila* (1987) builds for an hour on its drone of one deep pitch and its rapidly beating shadows.[13] This drone

is mottled with pings, and new higher pitches seep into the mixture. It's all heady stuff for those accustomed to melody or rhythm, but this is not simply pitches extended for hours. There are events: the groaning around the twelve-minute mark which might evoke a slowly moving cargo ship as it docks; the higher hum of the fourteen-minute mark accompanied by echoing ARP attacks. All this, as exquisite as it is, could be written off by less sympathetic listeners as difficult music. It is difficult, but it is not cynical because it does not discount beauty or pretend to know better. An hour into *Jetsun Mila*, the humming-drone begins, a sound I cannot classify but presume is meant to evoke Tibetan throat singing. It sounds like nothing like the previous material, and its volume grows until its bourdon has forced out the drones. It is a moment of grace. There is no explanation for it, no narrative or program or belief in some event that will justify what we hear; it is beautiful and incomprehensible because of its sounds alone, the fact that they do not develop or cohere into teleology. With ten minutes left before the end, this chorus starts its retreat, replaced with a stentorian single-pitched drone. It has its moment, and then it too dissipates. Radigue's music can come across as relentless, spare, even aloof, but it possesses a tenderness as well.

L'île ré-sonante (2005) begins with analog drones much like those in *Jetsun Mila*.[14] They continue for ten minutes, and then a miracle occurs: organ drone and female opera voices enter, women's rich contralto and soprano singing too vague to pin identification, but incontrovertibly warm and human. Such an event does not happen elsewhere in Radigue's catalog. Few moments in contemporary music are as beautiful or unantici-pated as this. The clash of genres, of drone and opera, leaves no hermeneutic clue by which we can orient the work. Its title offers the thinnest of traces: when the singing starts, we perhaps encounter a resonant island surrounded by an ocean of monot-onous drone, an island we quit after the 23 minute mark when

the singing and organ stop. Radigue is not cynical because beauty is at the forefront of her music. Experimentalist, yes, for she takes risks and gambles that her listeners will go along with her. But her gambits with the here-and-now as opposed to some future promise reveal that we have nothing to gain, or lose.

"Pump Cam / Debt Clock"

A speculative artwork

This will be a video installation. The screen is split in two. The left portion shows looped footage from a "pump cam" documenting oil spill resulting from the sinking of Deepwater Horizon.[1] The right portion shows live images of the US Debt Clock website, which shows ever escalating national debt.[2] The two images oddly share the same tempo, an implacable march toward ruination.

The fear is great because we know that we are living on borrowed time and borrowed money. It is easy to think that we who live in the privileged neighborhoods of the West Coast of the United States, in suburbs with universities and weekly farmer's markets and zoning ordinances against big-box stores, should be aware of the toll that our lifestyle exacts on the rest of the world. We can choose to shop only at stores promising sweatshop-free conditions. We can buy organic fair-trade coffee. We can register as independent voters, and take classes on non-violent communication. We can pass on to our children values of empathy, inclusion, and tolerance.

But these various gestures do not change the fact that, as our nation's most privileged caste, we enjoy this lifestyle on the backs of others who live very far away, people we will never see. And our lifestyle is now revealing itself as unsustainable. But our chagrin is not acute enough to prompt change. Instead, we lead our lives despite our latent misgivings, trying our best to be virtuous with acts of petty generosity. We are sincerely kind to our neighbors. We occasionally give a few dollars to the solicitors who beg outside of grocery stores. We organize fundraisers, sign online petitions, and give blood. We pretend that we are imperial, although we are really living in what Bret Easton Ellis

calls "post-empire"[3], and we now lack the moral superiority and the fiat power of wealth that used to reassure us.

[Curators' description]:

Finding footage of both the pump cam and debt clock were easy enough thanks to assiduous Internet archivists. We chose to pair the video installation with a recording of one of Wey's favorite rock bands, Stereolab, whose track "Crest" presents a steadily rising storm of noise that relents only after six minutes.[4]

"Apocalyptic Desire"

An essay

It is not contrary to reason to prefer the
destruction of the whole world to the scratching of my finger.
David Hume

Come Armageddon, come Armageddon, come!
Morrissey

The pleasure of returning to happy, beautiful art is straight-forward. Such beauty can uplift, comfort, and illuminate. It is essentially a positive phenomenon, something that it is pleasurable to experience for the first time, and to revisit subsequently.

But revisited apocalyptic art works differently. Aristotle and Edmund Burke first mapped this terrain: tragic art furnishes catharsis or purification, and sometimes audiences draw from it a salacious joy in watching hardship befall others. This is true, but today's technologies afford an experience not possible for either Aristotle or Burke: that of revisiting apocalypse, even gorging oneself with repeatedly listening, reading, and viewing it in art. What draws us back? There is a thrill in anticipating the dissolution we know is in store. The first time we encounter a tragic work, our ignorance of its outcome vouches for the purity of our intentions. We may even momentarily believe that the events of a novel, film, or recording are happening for the first time, that they are not predetermined. Their illusory contingency gives us leave to feel sincere emotion at their conclusion: so, shock at Emma Bovary's suicide, or desolation at the muted conclusion of Boards of Canada's *Tomorrow's Harvest*.[1] And for me, melancholy at the operatic drama in Tim Hecker's work,

especially his album *Virgins*. So when we return eternally to an apocalyptic artwork, is our motivation simply Schadenfreude?

I feel that there is more to our returns than sadism. Consider the preeminent medium of the return, the recording. Recordings are laboratories for studying how we re-experience art because we can listen to them again and again, enjoy their meandering triumphs, tragedies, and disappointments with the assurance that we know exactly what will happen. The mp3 does not do justice to our penchant as much as the twin circular phonographs, the record and the compact disc. Their circular shape recalls the Aristotelian model of the cosmos, with Earth at the center and other celestial bodies revolving around it. Early records were engraved with a spiral indentation whose last smallest revolution ended in a cul-de-sac, forcing the needle to jump backwards to its penultimate orbit, effectively closing the circle. If left unattended, such a record could play its last moments repeatedly, forever or at least until the electricity died. I ask you to regard recordings as orreries, mechanical models of solar systems whose orbits are already mapped, foregone conclusions.

The sixth century poet Boethius wrote his *Consolation of Philosophy* while awaiting execution for treason. In it, Boethius rails against the fickleness of Fortune and her spinning wheel that raises a man only to fling him down. When Boethius asks his confidant Lady Philosophy whether God predetermines existence, Philosophy responds with an extended metaphor explaining human behavior as the relationship of celestial bodies to an unmovable center. Because Boethius adhered to a geocentrism derived from Aristotle's, that center would have been Earth, with the moon, planets, and Sun all orbiting in perfectly circular trajectories.

Philosophy states that this unmovable center is God, the seat of providence: literally, seeing forward into the future.

Boethius saw the universe as a series of concentric spheres of

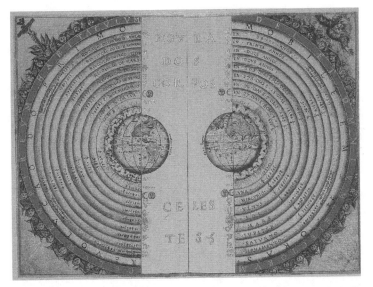

"An Aristotelian model of the universe, from Portuguese mapmaker Bartolomeu Velho, 1568".

movement, with each celestial body rotating about the fixed point of Earth. The motion of these bodies creates sound or, for Boethius, musica universalis. Wisdom demands reconciliation with God's plan, and since God was the unmovable center of the universe, the wise man does not try to break free from his orbit around God. The closer our orbit to the center, the closer we remain to the "stable simplicity of Providence"; the further our orbit from the center, the stronger the "chains of Fate".[2] Therefore, freedom results from harmonizing ourselves with God's gravitational pull.

One can only speculate as to how Boethius' universal music would have sounded. To flesh out my metaphor, suppose that Hecker's albums are Boethian orreries with their looped motives like bodies circling the Earth, or God. Hecker's albums *An Imaginary Country* and *Harmony in Ultraviolet* each contain first and last tracks that are essentially identical, meaning that back-to-back repeated listening would suggest seamless continuity

from end to beginning, a perfect revolution.[3] Several Hecker albums pit development against repetition. Hecker's music develops through track titles and drama, but repeats itself through loops of short and long duration. The pleasure in returning to tragic art amounts to the pleasure in contemplating this astronomical clockwork. The vagaries, the incidental details, the untold number of little things that could have happened differently and yet must conform to that "citadel of oneness", as Lady Philosophy calls it, all these things are subject to the Fate peculiar to the foregone conclusion of the already-made. An artwork revisited, whose orbit is as familiar as the lines on the face of one's beloved, travels a spacious arc across the heavens. With each successive rotation, we come to know and love it more, and also to develop ever great appetite for its twinges of pain and disintegration. I have listened to Hecker's *Ravedeath, 1972* perhaps over two hundred times, with its fragmented, noise-saturated opening of synths, forlorn Icelandic church organ, and piano.[4] I listen today as I have listened every time before, from the time I realized I knew the album more or less by heart. Each time, I hear the same events as a thread, a tragedy, although no story line is necessary. The music is too good to require a program. My love stems from the fact that I know every turn of the piece, that it is an exquisite tragedy always ending the same way. Hecker's albums are mechanical models that invite scrutiny with each additional listening because they are beautiful and because they end tragically. The recording spins, celestial bodies circle around, and Fate sits unmoved.

Ravedeath's "In the Fog III" contains two organ lines: a fast alternation between two voicings of the same pitch, and a slower cantus firmus, a simple argeggiated chord. The texture is eventually overridden with amorphous singing, organ undulations, and noise. The first time I heard this, I believed the falsehood that there was a drama unfolding before me. The second time, I began to recognize certain events, but the novelty

was still pervasive. By the tenth time, the recording grafted itself onto my memory, with the trajectory of its orbits assuming a sort of normalcy. Of course, they will sound this way, and conclude in this manner. The only freewill in the tragic artwork is in the listener's resignation, even acquiescence to processes she knows will end badly. There is no need to be a semiotician and impute agency into musical figures. The actors are we who revisit the artwork, happy that Fate will deal out no other outcome. In the tragic artwork, no new possibilities emerge. Tragic art contains its own apocalypse, well-known in advance.

As this Boethian metaphor intimates, the moments of centripetal stasis, of resignation to providence, are not the most alluring quality of Hecker's music, although they are quite beguiling. No, we listen repeatedly for the snatches of Icarian gumption, when a motive or theme suggests that it is possible to break away from the gravitational pull of Fate. Of course, to break away is impossible, and we listeners already knew it. Fate pulls initiative back down in its riptide. There is no redemption, and this is why tragic art draws us back. "Live Room" and "Live Room Out" are the centerpiece of Hecker's 2013 album *Virgins*, and they illustrate this phenomenon as well as any of the best passages in his catalog.[5] The former track seeps in tentatively with virginal keyboard as well as harmonium and room noise. The tide then flows with synths droning the ostinato, a chord progression that is lugubrious and beautiful enough to confound reason. Hecker's sort of beauty possesses a sort of imperiousness, a gorgon-like power that tears at our hearts rather than turning us to stone. But this beauty resides in the false supposition that it is possible to jump the track, to leave the engraved path. We savor the escape attempt every time we return, precisely because we know that escape is impossible, that Troy will always fall.

* *

Art often puts forward the illusion of hope. This is an illusion, of course, for naturally fictional characters are not real, do not possess agency, and thus cannot control their existence. Music is not alive.

Hope can incite me to disregard prior knowledge of the end of the artwork. I started *Madame Bovary* twice before putting it down each time, perhaps because I knew how that story would end. I knew that Emma Bovary is not a real person. I knew how she met her end. And yet I came to sympathize with and judge Emma, to regard her triumphs and miscalculations as real (real for her, at least) until I finally did feel shock at her suicide. Is art ethically obliged to indulge desire for hope and free will? If so, what are the ethical misdeeds of art that offers no hope? I speak here of stories of environmental, moral, and civic collapse, in which prophecy foresees disaster well in advance, and in which characters know that they lack free will. I speak also of the experience of listening repeatedly to drone works, knowing that they end as they begin without changing or evolving. Should art repudiate human agency? Is this nothing other than snuff art? In other words, what is the culpability of apocalyptic art?

These questions are particularly relevant to *La possibilité d'une île*, which alternates between the accounts of two characters: Daniel, a present-day superstar comedian, and Daniel25, his clone who lives several millennia in the future.[6] The relationship between these two accounts is initially unclear. Daniel is an Easton Ellis-like jaded enthusiast of porn and ultraviolence, whereas Daniel25's writing is dispassionate, referencing a leader called the "Supreme Sister" and obscure cataclysmic events. As the novel unfolds, these two accounts form a composite picture of global collapse. Despite Daniel's cynicism, he comes to believe that he will be resurrected as a clone in a utopia where aging, disease, and death will have disappeared, and where humans will be free to indulge in perpetual love and sensuality. This is his "possibility of an island", an era when a younger, perfected

version of himself will love an equally young and perfect woman. This struck me as a fantasy, as normally such an idea would strike Daniel. But caught up as he is with the Elohimite cult, which claims to have mastered genetic cloning, Daniel eventually views this possibility as certainty.

So in the present, Daniel's nihilism mixes with the hope that no matter how deplorable the human race is now, it will one day evolve to enjoy a happier, more peaceful existence. But the future's Daniel25 describes a nuclear war (occurring not long after Daniel's suicide) that culminated in atomic bomb detonations at both of the earth's poles, unleashing an ecological catastrophe called the Great Drying Out. All cities have been destroyed, with a small fraction of the human population surviving in primitive brutality. An even smaller number has survived as clones of the original Elohimite members, and these are scattered across the globe, each one occupying its own mechanized, hermetically sealed compound. Daniel25's account incrementally reveals that little of what Daniel envisioned about the future has come to pass. The clones, "neo-humans" as they call themselves, live in isolation from one another and communicate through computers. Neo-humans have lost all desire for food and sex, and experience no emotions beyond curiosity and disgust at the spectacle of human civilization. Neo-humans put to rest any fantasies of a better, more loving future world.

Houellebecq extends little genuine hope to Daniel, or at least no hope beyond that necessary to end his meaningless present life in order to prepare for an impossible future one. But Houellebecq affords no hope to Daniel25, who speaks of neo-human existence as machine-like and determined, and who knows ahead of time that his final act of leaving his compound for the outside world will change nothing. Daniel25's world is closed off from possibility and contingency. Like Daniel25's world, Houellebecq's novel is a system, a philosophical paradigm that relates separate phenomena to some intelligible

whole. And this system is wholly determined because Daniel is powerless to avoid the personal and global catastrophes he knows are coming, and Daniel25 put trays those catastrophes in retrospect as unavoidable and well-deserved.

Apocalyptic stories are usually open systems because they offer hope for the future, or at least delay hopeless revelations until the end of the story. *Terminator 2: Judgment Day* (1991), for instance, begins with Sarah Connor convinced of the inevitability of nuclear war. But Sarah's son John reasserts hope: there is "no fate but what we make." Even a dark tale like *Planets of the Apes* (1968) saves its most hopeless scene for the end. We don't know that Taylor has been on earth all along, an earth where humans have blasted themselves back to the stone age and where apes rule, until he discovers the Statue of Liberty rusted and all but buried in sand. Only then do we know the truth, and then the credits roll. But in *La possibilité d'une île*, there are no final surprises, and readers know that the end for Daniel (i.e., suicide) and Daniel25(i.e., solitary reflection) will change nothing in the world at large. Nor does *La possibilité d'une île* contain characters who would change the prevailing theory that humanity is doomed, no actions that would cast doubt on this theory, no moments of randomness that might interrupt the fatalist narrative. Like all good tragedies, *La possibilité* puts us in the comfortable position of watching a train-wreck from a distance. And this is pleasurable.

* *

During the early 1980s, William Basinski laid down a large amount of synthesized fragments consisting of tonal, consonant melodies onto magnetic tape. When in 2001 Basinski began to archive this material onto digital media, the intervening years had so damaged the tape that the very act of replay scraped away the magnetized particles that encoded the sound. Time and the

effort to save his music from time destroyed Basinski's music. He promptly recognized the serendipity and released his findings as a reaction to the attacks of 11 September 2001. *The Disintegration Loops* is apocalyptic art, art that represents and aestheticizes the end of the world.[7] This ambient work forces reconsideration of the old dilemma: why do we enjoy watching someone else's suffering?

We can recall, for instance, Leontinus in Plato's *Republic*, who is tormented by his desire to look at corpses lying at the feet of the local executioner. He tries to look away, but then gives into temptation and rushes at the bodies to gawk.[8] For Plato, Leontinus is merely acting on an irrational desire. But Burke sees in such desire a predictable, even logical behavior. As long as the suffering we behold in art occurs to someone else, not ourselves, it is "capable of grafting a delight on wretchedness, misery, and death itself."[9] We might simply associate Burke's and Plato's observations as other examples of Aristotelian catharsis, a purification through beholding tragic events. But here, delight in watching others' pain is possible only when we feel safe and out of harm's way. Burke puts it best when he imagines an earthquake that would level London. Crowds safely distant during the catastrophe would flock to the capital, and the curiosity to see the rubble would eat at even those who had never before wanted to visit London. Burke, Aristotle, and Plato thus point to Schadenfreude, the delight we experience at the suffering of others. But something else is at play in the preponderance of apocalypse-themed art during the past several decades. After all, many know that the end is coming. We relish art that speaks of this end, not because it is merely art and not real, but to the contrary, because it is true, truer than our manners and customs that we learn in order to coexist, in order not to slaughter one another. My absorption with apocalyptic stories stems from some prurient desire to know more about what the aftermath of apocalypse would be. The thrill of gore and destruction is vivid

because we could so easily be victims next, and we are wondering how it would feel to be victims. There is also the very real desire for some sort of comeuppance for our culture's perceived sins and iniquities. Evangelical Christians who believe in the Rapture take comfort that the event will reward the just and punish the wicked. Progressives shudder with delight in imagining catastrophic climactic changes that will finally repudiate carbon-based capitalism and avarice. In many apocalyptic fantasies, we find it acceptable to imagine the end of our own lives, just so long as any behavior we condemn is summarily punished.

Apocalyptic desire lurks somewhere between Schadenfreude and masochism. It is not simply the desire for someone else's apocalypse, but scurries back and forth between imagined dooms of someone else and the self. Are we no better than poor Leontinus, who wants to avert his eyes but cannot? Leontinus himself may not be so poor; he is a very vocal victim, at any rate, who spends energy announcing his succumbing to temptation that might be better used fighting temptation. I do the same when I listen to Basinski's *The Disintegration Loops*. The composite artwork, its photos and backstory, make it well nigh impossible either to ignore memories of the September 11th attacks, or to avoid viewing those events with melancholic pleasure. Its four album covers capture the Manhattan skyline at successive moments that show how smoke and debris overtake the city. But we see nothing from the street, of course; no planes, no people jumping from the towers, and the shots are taken from such a remove that it's easy to be metaphorical and read the events of that day, as well as the image of those collapsed buildings, as symbols of the decay of the American empire. As if one could read trauma and disaster, could abstract private pain and loss, and make sense or art out of the anesthetized data.

This is not a critique of apocalyptic art or of the artists who make it, but only of myself, the reasons why I enjoy it. At the end

of *Disintegration Loops 1.1*, when the synthesizer loops have entirely disappeared, the only remaining sound is the lingering tape groan. It is recurring, the only vestige of sound on a tape that has been scraped clean of dust and music. Is this groan all that will remain after the civilization that built the towers has also ground itself down into dust? *Disintegration Loops 2.1* is even bleaker. A sustained note in synthesized high strings accompanied by intermittent tape static, a walking bass line from a harp, occasional French horn, and all of this slowly repeating like a funeral cortège. This music also slowly recedes, is overtaken by noise, and is eaten away like a corpse. And yet Basinski has made this so beautiful, so invincibly and serenely beautiful, that I can half-believe that the collapse of my culture is also beautiful, or at least will be regarded as tragically beautiful after an appropriate period of mourning has passed. Violence of such scale was riveting to many Americans because it hit us on our native soil, and also because it calmly posed unspeakable questions: how long from the moment of the planes' impact to the time their passengers were incinerated? Did they feel any pain, or were they destroyed immediately? Could they even think, "I've just struck a building"? What does a body feel when it jumps from over a hundred stories to the ground? How awful must it have been inside the building to prompt those above the entry point of the planes to jump to their deaths?

This is why I am uncomfortable with my great love for Basinski's *The Disintegration Loops*. These recordings indulge my apocalyptic desire, my curiosity about destruction of bodies. In these tracks, all the gore vanishes, and with it, my last instinct for sympathy.

"The Chelyabinsk meteoroid"

A speculative artwork

I thought initially what they all must have thought when they saw a streak of light that was brighter than the sun: that this was the end. But it was not the end, though the sonic boom gave a presentiment of that sound that will be louder than any other sound ever heard. The rock that entered the atmosphere over Alaska on 15 February 2013 and broke up over the Urals gave a more precious gift than a shudder of a near-miss. Those not present could experience it only through video footage taken with surveillance cameras and dashboard mini-cams, the indispensable tool for thwarting cops looking to shake down innocent motorists.

I did not know this when I first saw the videos. I instead wondered at the luck of multiple motorists who all just happened to be filming at the right time. For how could anyone have the presence of mind to see the fireball, then take out a phone or camera within the few moments before the sky turned blinding, and retinas would seem to be seared out of their sockets? Better still was the footage from what (I imagine) is the clock or bell tower of the town. There, one could follow the bizarre, rapid transit of the shadows cast by buildings and trees as the molten iron flew by.

The shadows cast pirouettes that by rights should have taken hours to accomplish. And what shadows! Shadows in the wrong places, the definition of a nightmare. Over 1500 people suffered injuries, most of which were due to shattered glass falling onto skin or eyes. The sonic boom sent shock waves that punished anyone who thought to look up. It was a gorgon-moment. So those of us shielded like Perseus with our footage and safe distance could regard this event as a perfect apocalyptic artwork.

[Curators' description; video available at
http://www.joannademers.com]:

We realized this speculative artwork as a diorama that depicts Chelyabinsk, a large town on the edge of a Siberian wilderness. A video installation of the diorama focuses on the diorama only, but beyond the camera is a bright light that emulates the movement of the meteor. The footage focuses on the uncanny movement of shadows; this movement is repeated through looping, and slowed down to domesticate the most unnerving of calamities.

"After Apocalypse"

An essay

...people are talking about apocalypse and the last judgment, because they do not know that there will be neither apocalypse nor last judgment ...such things would serve no purpose since the world will quite happily fall apart by itself and go to wrack and ruin so that everything may begin again...
László Krasznahorkai

Nothing that is past is an object of choice. No one chooses to have sacked Troy; for no one deliberates about the past, but about what is future and contingent, while what is past is not capable of not having taken place....
Aristotle

The cliffs of the Palos Verdes peninsula are strewn with remnants of military outposts. Built atop one such ruin is the Friendship Bell in San Pedro, an outdoor Buddhist monument that the South Korean government donated as thanks for US participation in the Korean War. This bell sits directly on a large bunker that belonged to Fort MacArthur, a defense base built in the late-nineteenth century whose placement on the peak of the Point Fermin promontory gives it a 270-degree view of the Pacific Ocean. On a clear day, soldiers inside this bunker would have been able to survey everything from San Clemente to the south, to Catalina Island to the southwest, and to the cliffs of Abalone Cove just to the northwest. The view from this lookout post is breathtaking even to those who are accustomed to Southern California's coast. Immediately adjacent to the bell and its armored shelter underneath is a cement circle perhaps 50 feet in diameter. This large circle contains a smaller concentric circle

made of concrete. It is not clear what purpose this circle served, only that it no longer serves any purpose. It might have been the part of a large gun or cannon that could pivot on its central circle to aim at warships. Or, it could be a cap to block the aperture occupied by a missile. There are several other strange circles in the lawn immediately to the north of the bell. Concrete here barely peaks through green grass. During World War II, Fort MacArthur was an important lookout post for detecting Japanese ships and submarines. In the early days of the Cold War, Fort MacArthur was outfitted with surface-to-air Nike missiles that protected the US against a Soviet air attack. In subsequent years, the Nike program was expanded to encompass surface-to-surface applications. Fort MacArthur's Nike missiles might well have been outfitted with nuclear warheads.

To the north of Palos Verdes is the coastal city of Redondo Beach, among whose many public parks is Hopkins Wilderness Park. Here lies a hilly stretch of local flora crowned with a manmade stream and duck-and-turtle pond. The park is overflowing with brush, eucalyptus, and blackberry bushes that produce sweet fruit from April through August. Parents bring their children to run around and pick berries in this small oasis only 24 miles from downtown Los Angeles. During the 1960s before it became a park, the area now known as Hopkins was the site of a Nike Radar installation. Cement platforms that perhaps served as the foundations for radar antennae are all that remain of the station. Children today stomp and build make-believe forts on the spots where these instruments watched for incoming missiles and were primed to guide outgoing missiles destined for Moscow or Leningrad or Vladivostok.

There is a wistful pleasure in contemplating the vestiges of an apocalypse that never occurred. For anticipation of apocalypse entails two sentiments at cross-purposes: the dread of what will happen, and the certainty that it will happen. Clearly, the US government, the soldiers manning the bunkers in Fort

MacArthur, and the residents of San Pedro and Palos Verdes whose windows were shattered when the Point Fermin bunker crew practiced did not desire World War III. It is difficult to imagine such an attack when looking out at the cobalt-blue sea. And yet, armaments and fortifications can draw forth that which they were conceived to destroy. Those who grew up in the shadow of unrealized mass destruction are both relieved and disappointed that apocalypse never took place. In the case of nuclear missiles, apocalyptic desire could emerge from a curiosity to see what havoc a newly developed weapon could unleash. For no one during the Cold War got to see how well this doomsday equipment worked. There were underground and surface tests, of course; the deserts of southeastern Nevada and numerous South Pacific atolls will forever be uninhabitable because of such trials. But tests are not real attacks, and the vestiges of apocalyptic anticipation contain an unsated curiosity to see how bad things could have become.

* *

There are so many apocalyptic scenarios that the very idea has been bankrupted of any shock. Apocalypse can be fantastical or real. It can result from pollution and defilement of the planet, of battles and wars that also despoil the Earth, of overpopulation, of attacks from off-world beings, or of scientific calamity, when medicines supposedly engineered to heal us instead turn us into abhorrent monsters. Jews, Christians, Mayans, and doubtless many others have spoken of preordained apocalypse, and some even believe that they can hasten, or at least prepare for, the end through prayer and virtuous living. And one of our favorite terms today is "post-apocalyptic". It is an oxymoron, for what future can exist after the end? In Nevil Shute's novel *On the Beach*, the Australians patiently await the poisonous cloud from the Northern Hemisphere that has already killed most of the world's

population.[1] They watch the pouring rain, knowing that the rain soon will pour down radiation onto their children's heads. *On the Beach* is courageous enough to portray the result of nuclear war: true apocalypse, total death of the human race. Most post-apocalyptic thought, on the other hand, is ethically perilous because it indulges in pathological fantasy, a scenario in which a few survive to struggle with the dilemmas humanity couldn't resolve when it had a chance.

Consider, on the one hand, fundamentalist Christian narratives of the Rapture, and on the other hand, secular entertainment films like the *Terminator* and *Mad Max* franchises, *The Day After* and *The Testament*. Despite the beliefs espoused in these two cosmologies (conservative, faith-based vs. liberal, science-based), both show apocalypse from the point of view of virtuous survivors who must fight evil. Post-apocalypse is morality play. According to the narrative of the Rapture, the truly virtuous simply ascend to Heaven, leaving behind the venial and the irredeemable. This fantasy, of course, tempts the audience to identify with the venial, those who eventually will end up in heaven after struggle and repentance. The story is never told from the point of view of the irredeemable ones, for how could we identify ourselves with monsters? The savagery with which the good are set apart from the bad in these stories is astounding. Post-apocalyptic thought is a drive toward death, but the death of others rather than ourselves.

But post-apocalyptic thought is only one type of thought, and a very limited one at that. The real apocalypse will be absolute. A few of us have accepted this as inevitable, but most have not. Instead, many of my generation never progressed beyond a 1986-mindset. We search for remnants of post-apocalypse. We have devised phrases like "post-apocalyptic chic" and "apocalyptic sublime", and speculate on life after an apocalypse that never took place. Basinski's *The River* is just such a work.[2] It begins with the hum of crickets or frogs, or some mechanized approximation

of such creatures. A repeated organ three-note-pattern (V-II-I) enters, and will repeat for the length of the piece. The sound is lo-fi, with echoed iterations of crickets sounding dirty and throbbing steadily as if just out of earshot. We read in its liner notes that *The River* was composed in 1982 in New York from tape loops and shortwave radio. Basinski put the tapes away, worked in an antique shop, and only in the late 1990s began making inroads into the Brooklyn art scene. *The River* was released in 2002, 20 years after its creation, and launched Basinski's career as a composer of electronica.

It is difficult to pinpoint the time during which *The River* exists or existed. It could be 1982, although why privilege this particular year if it was heard by so few people when it was first created, and if it reflects nothing of the trends of its time? It could count rather as a product of 2002, but that doesn't quite fit either, since it was already an old piece by then. And its shortwave sounds only worsen the confusion. By some standards, shortwave is a relic, obsolete thanks to internet radio. Its transmissions are inevitably fuzzy and full of static. It ages anything it broadcasts, even something from the present. So these transmissions come from the past and yet they also intimate the future, perhaps the last utterance we will have made as humans after we have expired as a race. Shortwave radio transmissions can travel into outer space, resounding in emptiness even if we have passed on. *The River* is an acoustic message-in-a-bottle, something before and after we lived.

Quentin Meillassoux targets this range of time either before or after any human as the blindspot for modern philosophy.[3] If subjectivity is the necessary condition for all thought, if we can never conceive of the object-in-itself, then philosophical thought (according to Kant's rules) is impossible in pre- and post-human time. And this, Meillassoux writes, should bother us, shake us to our very core. For scientific thought has already developed manners of speaking about that which we have not necessarily

witnessed, things for which empirical observation during the moment is impossible. What good can come from philosophical thought that, contrary to every gain of Copernicus and Galileo, insists on the centrality of subjectivity? We really are too impressed with ourselves if we cannot conceive of a world without us.

So *The River* might be a courageous piece that does some of the work Meillassoux calls for in contemporary philosophy. We hear the sounds of Earth divested of its human inhabitants, perhaps a planet on technological standby, its gadgets slowly winding down until they stop functioning altogether. That this is a truer, more just type of apocalyptic thought, I can only imagine. Horror, sentimentality, tragedy: these are the qualities of the insincere suicidal who wants loved ones to imagine her absence in order to drum up affection she feels she lacks. There is nothing serious in this sort of apocalyptic thought; it is manifestly anti-apocalyptic, it wants nothing of the sort.

* *

Tony Barrell and Rick Tanaka refer to a "continuity syndrome" in contemporary Japan, the fact that the American occupation and the defeated Japanese government alike agreed on retaining the Emperor.[4] This figurehead was the man-god who tacitly or explicitly, depending on who is relating the history, led Japan to pillage and invade China, Taiwan, New Guinea, Singapore, Malaysia, Korea, and the Philippines. Few countries know as much about apocalypse as Japan, which experienced it first-hand in the form of the firebombing of Tokyo as well as the nuclear bombings of Hiroshima and Nagasaki. Traces of apocalypse are audible in Japanese postwar popular music, intimations that the loving replications and improvements on American rock 'n' roll and pop are seeded with doubt and nihilism. This is especially true of the music of Les Rallizes Dénudés, a noise-rock band

active from the late 1960s through the early 1980s and led by vocalist/guitarist Takeshi Mizutani. LRD was sympathetic to the Japanese Communist Party, and distributed communist pamphlets at junior high schools. The group were fixtures in a clique that loved American pop culture even as it criticized American imperialism in Vietnam. LRD, in other words, diagnosed and treated Japan's continuity syndrome, and did so through enacting its own apocalypses in music. And so LRD desired apocalypse because it recognized the potential for apocalypse inherent in the curatives and progress of Japan, the postwar miracle that transformed the country from feudal ruins to an economic superpower by the mid-1950s.

In a 1977 performance of "Enter the Mirror", Mizutani's voice rings out on top of a guitar that simmers at the divide between controlled servitude and rebellious feedback, brain-hemorrhaging sharpened-steel pain.[5] Mizutani excelled at gauging the reverberation speed of his vocal microphone. The reverberation in this bootleg beats at exactly the rate of four to every one beat of the song, echoes beating out sixteenth notes. His voice somehow conjures a soul out of the simple song whose bassline should be too heavy and plodding, yet is instead arresting. "Night of the Assassins" takes its bassline from the hysterical chorus of Little Peggy March's "I Will Follow Him" (1963). I love him, Peggy shouts again and again, and I'll follow him forever. I do not know whether Mizutani intended the associations of the March song to bleed into "Night of the Assassins". For non-Japanese speakers, nearly everything about LRD is unclear, and rumors are left unconfirmed. The best resource is Julian Cope's *Japrocksampler*, a survey of postwar Japanese pop that is invaluable, yet whose assertions too often lack citations to inspire much confidence.[6] But we go with what we have, and if Cope's history contains myth, even the myth is important because it has been accepted as fact by LRD fans. LRD was Mizutani's invention, and Mizutani invented himself at Kyoto's Doshisha

University as a French intellectual who dressed in black, grew his hair long, and spoke a Japanese sprinkled with French and English affectations. Mizutani tended toward folk rock, and LRD seemed poised for success. But in March 1970 LRD's bassist Moriyasu Wakabayashi along with eight others hijacked a Japanese Airlines jet using pipe bombs and samurai swords. The fallout of this event was calamitous for Mizutani and LRD. Wakabayashi ended up in Pyongyang, North Korea after the hijackers relented on their initial demand to fly to Cuba. All of the passengers were eventually released unharmed, but the CIA concluded that Japanese underground musicians posed a threat to American interests in East Asia. LRD disbanded; other musicians avoided Mizutani, who was tailed by the CIA for the next several months. Mizutani went into hiding, first in a posh neighborhood in Tokyo and then on remote Mt. Osore in northern Honshu, the gateway to Hell according to local legend. Cope paints a sadly beautiful picture of Mizutani's subsequent career as a hermit who refused to make studio recordings and only rarely let himself be cajoled into performing live with musicians who accepted his dictates for stripped-down rock saturated in noise, deafening bass, and strict adherence to a canon of fifteen or so songs. Mizutani avoided the recording studio, but did release pristine psychedelic tracks like "Kioku Ha Toi". But Mizutani's vision for his live shows is clear because he recorded so many of them, and they are available as coveted vinyl or CD bootlegs and YouTube downloads.

LRD recordings are dirty, overloaded with tape noise or recorder hum. They are also beautiful; the better ones feature Mizutani's voice partaking in a ghostly reverberation counterpoint with the instruments such that the voice carves the implacable bassline into eighths or triplets. Mizutani was an idealistic young musician persecuted for his associations with terrorists, who withdrew to a mountain retreat. Cope would have it that Mizutani has been waiting for decades for the

widespread acclaim he is convinced is impending. It makes a lovely story. And if it is true, then all children of the Cold War have something in common with Mizutani. They all wait, biding their time for the liberation that recognition will bring. The end is coming, and Mizutani's music faces that end with honesty. Its monochromatic desolation, its technical flaws, its single-mindedness persist with the certainty of someone who has drawn up his will, who has put his affairs into order. And sickened as Mizutani was with his country's war atrocities and subservience to American imperialists, it is only natural that LRD marks time for the end, even invites it. "Night of the Assassins" follows wherever its lover or leader goes. It is a matter of waiting in a lonely outpost for the salvation that is imminent no matter how long it takes to arrive.

Endnotes

Preface

Epigraph. Georg Wilhelm Friedrich Hegel, *Aesthetics: Lectures on Fine Arts, vol. 1*. Trans. TM Knox (Oxford: Clarendon, 1975), 55.

Epigraph. Percy Bysshe Shelley, *Laon and Cythna*. In *The Major Works* (New York: Oxford University Press, 2003), Canto I, Stanza 1, lines 134-145.

1 Carolyn Abbate, "Music—Drastic or Gnostic?" *Critical Inquiry* 30 (Spring 2004): 505-536; Vladimir Jankélévitch, *Music and the Ineffable*, trans. by Carolyn Abbate (Princeton, NJ: Princeton University Press), 2003.

2 Joanna Demers, "On Meaninglessness," *Journal of Popular Music Studies* 23/2 (2011): 195-199.

3 Personal communication, 3 April 2013.

4 Michael Gallope, Brian Kane, Steven Rings, James Hepokoski, Judy Lochhead, Michael J. Puri, and James R. Currie, "Vladimir Jankélévitch's Philosophy of Music," *Journal of the American Musicological Society* 65/1 (Spring 2012): 215-256.

5 Ibid., 221-222.

6 Ibid., 224.

7 Hegel, *Aesthetics: Lectures on Fine Art*, vol.1, 55.

8 Joanna Demers, "Ambient Drone and Apocalypse," *Current Musicology* No. 95 (Spring 2013): 103-112.

9 Tim Mulgan, *Ethics for a Broken World: Imagining Philosophy After Catastrophe* (Montréal: McGill-Queen's University Press, 2011).

10 Reza Negarestani, *Cyclonopedia: Complicity with Anonymous Materials* (Victoria, Australia: Re.press, 2008).

11 Low, "Do You Know How to Waltz?", Live at Rock the Garden 2013. https://www.youtube.com/watch?v=zI5-MuV5NSo (accessed 9 December 2014). See the description

of the performance as well as the ensuing debate among commenters in Andrea Swensson, "The audacity of Low: What does a band 'owe' us when we pay to see them perform?" *The Current* (18 June 2013). http://blog.the current.org/2013/06/the-audacity-of-low-what-does-a-band-owe-us-when-we-pay-to-see-them-perform/ (accessed 9 December 2014).

12 Low. *The Curtain Hits the Cast*. Plain Recordings, 1996. Plain 172-2.

13 The controversy of Low's June 2013 performance eventually led to a follow-up event, "Drone Not Drones", a 28-hour drone marathon at the Cedar Cultural Center in Minneapolis featuring numerous musicians. This took place on 7-8 February 2014.

14 Tim Morton, *The Ecological Thought* (Cambridge, MA: Harvard University Press, 2012), 130.

15 Tim Morton, *Hyperobjects: Philosophy and Ecology After the End of the World* (Minneapolis: University of Minnesota Press, 2013), 107-8.

Commentaries on the Apocalypse

1 John Williams, *The Illustrated Beatus: A Corpus of the Illustrations of the Commentary on the Apocalypse* (Harvey Miller, 1994).

2 *The New American Bible.* (Iowa Falls: World Bible Publishers, 1987), 1372.

3 Otto Pächt, *Book Illumination in the Middle Ages: An Introduction*, trans. Kay Davenport (London: Harvey Miller, 1986), 161.

4 Georg Wilhelm Friedrich Hegel, *Science of Logic*, trans. AV Miller (New York: Humanity Books, 1969), 130.

The End of Happiness, The End of the World

1 Celer. *Salvaged Violets*. Infraction, 2010. INFX 050.

2 Herodotus, *Histories*, trans. Aubrey de Sélincourt (London : Penguin, 2003), 16.

3 Ibid., 23.

4 Near-verbatim transcription of Aristotle, *Nicomachean Ethics* I: 1, 1094a1-18. In *The Complete Works of Aristotle. The Revised Oxford Translation*, Vol. 2, ed. Jonathan Barnes, trans. W.D. Ross (Princeton: Princeton University Press, 1984), 1729.

5 Aristotle, *Nicomachean Ethics* I: 10, 1100a10. In *The Complete Works of Aristotle. The Revised Oxford Translation, Vol. 2*, ed. Jonathan Barnes, trans. W.D. Ross (Princeton: Princeton University Press, 1984), 1738.

6 Plato, *Gorgias* 512e. In *Complete Works*, ed. John M. Cooper, trans. G.M.A. Grube, rev. C.D.C. Reeve (Indianapolis: Hackett, 1997), 856.

7 Most of Celer's catalog can be found at http://www.celer.bandcamp.com.

8 Boethius, *The Consolation of Philosophy*, trans. Victor Watts (New York: Penguin, 1999), 27-28.

9 Aristotle *Nicomachean Ethics* X:7, 1177b33. In *The Complete Works of Aristotle. The Revised Oxford Translation, Vol. 2*, ed. Jonathan Barnes, trans. W.D. Ross (Princeton: Princeton University Press, 1984), 1861.

10 Fyodor Dostoyevsky, *The Idiot*, trans. Constance Garnett (New York: Bantam, 1988), 57.

11 Ibid., 57.

12 Ibid., 219.

13 Celer, *An Immensity Merely to Save Life*. https://celer .bandcamp.com/album/an-immensity-merely-to-save-life (accessed 29 December 2014).

14 Hegel, *Science of Logic*, 129.

15 Herodotus, 93.

16 Ibid., 94.

17 Thomas Köner. *Novaya Zemlya*. Touch, 2011. TO:85.

18 Thomas Köner. *Nunatuk – Teimo – Permafrost*. Type

Recordings, 2010. TYPE 072.

The Big Bang

1 Kyle Bobby Dunn. *A Young Person's Guide to Kyle Bobby Dunn*. Low Point, 2010. LP033.

Manifest

1 William Basinski. *Melancholia*. Temporary Residence, 2014. TRR236.

2 Pliny the Elder, *Natural History: A Selection*, trans. John F. Healy (London: Penguin, 1991), 114.

3 Celer. *Engaged Touches*. Home Normal, 2009. home n002.

4 Celer. *Panoramic Dreams Bathed in Seldomness*. Basses fréquences, 2010. BF27.

5 Celer. *Brittle*. Low Point, 2009. LP028; *In Escaping Lakes*. Slow Flow Rec, 2009. WW1001.

6 Celer. *Merkin*. 2009. https://celer.bandcamp.com/album /merkin (accessed on 12 December 2014).

7 Isidore of Seville. *The Etymologies of Isidore of Seville*, trans. Stephen A. Barney, W.J. Lewis, J.A. Beach, and Oliver Berghof (Cambridge: Cambridge University Press, 2006), 320.

8 Ibid., 321.

9 Ibid., 324-326.

10 Herodotus, 304.

11 Paul Virilio, "A Pitiless Art," in *Art and Fear*, trans. Julie Rose, 27-65 (London: Continuum, 2003), 39.

12 W.G. Sebald, *The Rings of Saturn*, trans. Michael Hulse (New York: New Directions, 1998), 16-17.

13 Aristotle, *History of Animals* I;1, 488b 25-26.9. In *The Complete Works of Aristotle. The Revised Oxford Translation, Vol. 1*, ed. Jonathan Barnes, trans. d'A.W. Thompson (Princeton: Princeton University Press, 1984), 778.

14 Christopher P. Long, *Aristotle on the Nature of Truth* (New

York: Cambridge University Press, 2011).

15 Robert Burton, *The Anatomy of Melancholy* (New York: New York Review of Books, 2001), I:48.

16 Isidore of Seville, 9.

17 Ibid., 9.

18 Susanne Lange, *Bernd and Hilla Becher: Life and Work*, trans. Jeremy Gaines (Cambridge, Mass: MIT Press, 2006).

19 Celer. *Butterflies*. 2011. https://celer.bandcamp.com/album /butterflies (accessed on 12 December 2014).

20 Andreas Gursky, *Andreas Gursky: Works 80-08*, ed. Martin Hentschel (Hatje Cantz, 2011).

21 *Manufactured Landscapes*, dir. Jennifer Baichwal. Zeitgeist Films, 2006.

Photojournalism of the Fall

1 Gore Vidal, *Julian* (New York: Vintage, 1992), 501.

2 Pseudo-Dionysius, *The Complete Works*, trans. Colm Luibheid (New York: Paulist Press, 1987), 52-3.

3 Ibid., 54.

Radigue's Wager

1 Blaise Pascal, *Pensées*, ed. Michel Le Guern. Paris : Éditions Gallimard, 2007. Fragment 307, pg. 213.

2 Theodor W. Adorno, "Cultural Criticism and Society," in *Prisms*, trans. Samuel M. Weber, 17-34 (Cambridge, MA: MIT Press, 1967), 34.

3 Theodor W. Adorno, *Aesthetic Theory*, trans. Robert Hullot-Kentor (Minneapolis: University of Minnesota Press, 1997), pg. 53: "Loyalty to the image of beauty results in an idiosyncratic reaction against it. This loyalty demands tension and ultimately turns against its resolution. The loss of tension, an insignificance of the relation of parts to the whole, is the strongest objection to be made against much contemporary art."

4 Michel Houellebecq, *La possibilité d'une île* (Paris : Fayard, 2005), 145.

5 Images from Chad Attie's *Contempt* exhibition can be found at http://www.chadattie.com/contempt.html (accessed 18 December 2014).

6 Morton, *Hyperobjects*, 146.

7 Jonathan Barnes, ed. and trans. *Early Greek Philosophy* (London: Penguin, 1987), 206.

8 Snorri Sturluson, *Edda*, trans. Anthony Faulkes (London : Everyman, 1987), 9.

9 Pascal, fragment 187, pg. 161.

10 Éliane Radigue. *Adnos I-III*. Important Records, 2013. IMPREC 028.

11 Barnes, 77-84.

12 Houellebecq, 150-151.

13 Éliane Radigue. *Jetsun Mila*. Lovely Music, 2007. LCD 2003.

14 Éliane Radigue. *L'île ré-sonante*. Shiin, 2005. Shiin 1.

Pump Cam / Debt Clock

1 "The Deepwater Horizon spill 27th-28th May 2010" https://www.youtube.com/watch?v=1DefFP6dezA (accessed 29 July 2014).

2 "U.S. Debt Clock", http://www.usdebtclock.org/ (accessed 29 July 2014).

3 Bret Easton Ellis, "Notes on Charlie Sheen and the End of Empire," *The Daily Beast* (15 March 2011), http://www.thedailybeast.com/articles/2011/03/16/bret-easton-ellis-notes-on-charlie-sheen-and-the-end-of-empire.html (accessed on 18 December 2014).

4 Stereolab. *Transient Random-Noise Bursts With Announcements*. Elektra 1993. 9 61536-2.

Apocalyptic Desire

Epigraph. David Hume, *A Treatise of Human Nature*. Book II, Part

III, Section III. http://www.gutenberg.org/files/4705/4705-h/4705-h.htm (accessed 19 December 2014).

Epigraph. Morrissey, "Everyday Is Like Sunday," from *Viva Hate*. HMV 1988. 064 790180 1.

1 Gustave Flaubert, *Madame Bovary* (Paris: Gallimard, 2001); Boards of Canada. *Tomorrow's Harvest*. Warp 2013. WARPCD257.

2 Boethius,105.

3 Tim Hecker. *An Imaginary Country*. Kranky 2009. Krank 130; Tim Hecker. *Harmony In Ultraviolet*. Kranky 2006. Krank 102.

4 Tim Hecker. *Ravedeath, 1972*. Kranky 2011. Krank 154.

5 Tim Hecker. *Virgins*. Warp 2013. Krank 183.

6 Houellebecq, *La possibilité d'une île*.

7 William Basinski. *The Disintegration Loops*. Discs 1-4. Musex 2001. 20620202, 20620202, 20620304, 20620305.

8 Plato. *The Republic*. 439e6-440a3. In *Complete Works*, ed. John M. Cooper, trans. G.M.A. Grube, rev. C.D.C. Reeve (Indianapolis: Hackett, 1997), 1071.

9 Edmund Burke, *A Philosophical Enquiry into the Origin of our Ideas of the Sublime and Beautiful*, ed. Adam Phillips (Oxford: Oxford University Press, 1990), pg. 41.

After Apocalypse

Epigraph. László Krasznahorkai, *The Melancholy of Resistance*, trans. George Szirtes (New York: New Directions, 2000), 103.

Epigraph. Aristotle. *Nicomachean Ethics*. VI: 2, 1139b5-8. In *The Complete Works of Aristotle. The Revised Oxford Translation, Vol. 2*, ed. Jonathan Barnes, trans. W.D. Ross (Princeton: Princeton University Press, 1984), 1799.

1 Nevil Shute, *On the Beach* (New York: Vintage, 2010).

2 William Basinski. *The River*. Musex 2008. 20620702.

3 Quentin Meillassoux, *After Finitude: An Essay on the Necessity of Contingency* (London: Continuum, 2008).

4 Tony Barrell and Rick Tanaka, *Higher Than Heaven: Japan,*

War, and Everything (Strawberry Hills, Australia: Private Guy, 1995).

5 Les Rallizes Dénudés. *Le 12 mars 1977 à Tachikawa*. Level Over [year unknown]. 001.

6 Julian Cope, *Japrocksampler: How the Post-War Japanese Blew Their Minds On Rock 'n' Roll* (London: Bloomsbury, 2007).

Bibliography

Abbate, Carolyn. "Music—Drastic or Gnostic?" *Critical Inquiry* 30 (Spring 2004): 505-536.

Adorno, Theodor W. *Aesthetic Theory.* Trans. Robert Hullot-Kentor. Minneapolis: University of Minnesota Press, 1997.

——. "Cultural Criticism and Society." In *Prisms.* Trans. Samuel M. Weber. 17-34. Cambridge, MA: MIT Press, 1967.

Aristotle, *History of Animals.* In *The Complete Works of Aristotle. The Revised Oxford Translation, Vol. 1.* Ed. Jonathan Barnes. Trans. d'A.W. Thompson. Princeton: Princeton University Press, 1984.

——. *Nicomachean Ethics.* In *The Complete Works of Aristotle. The Revised Oxford Translation, Vol. 2.* Ed. Jonathan Barnes. Trans. W.D. Ross. Princeton: Princeton University Press, 1984.

Attie, Chad. *Contempt* exhibition. http://www.chadattie.com/con tempt.html (accessed 18 December 2014).

Barnes, Jonathan, ed. and trans. *Early Greek Philosophy.* London: Penguin, 1987.

Barrell, Tony and Rick Tanaka. *Higher Than Heaven: Japan, War, and Everything.* Strawberry Hills, Australia: Private Guy, 1995.

Boethius. *The Consolation of Philosophy.* Trans. Victor Watts. New York: Penguin, 1999.

Burke, Edmund. *A Philosophical Enquiry into the Origin of our Ideas of the Sublime and Beautiful.* Ed. Adam Phillips. Oxford: Oxford University Press, 1990.

Burton, Robert. *The Anatomy of Melancholy.* New York: New York Review of Books, 2001.

Cope, Julian. *Japrocksampler: How the Post-War Japanese Blew Their Minds On Rock 'n' Roll.* London: Bloomsbury, 2007.

Demers, Joanna. "Ambient Drone and Apocalypse." *Current*

Musicology No. 95 (Spring 2013): 103-112.

— —. "On Meaninglessness." *Journal of Popular Music Studies* 23/2 (2011): 195-199.

Dostoyevsky, Fyodor. *The Idiot.* Trans. Constance Garnett. New York: Bantam, 1988.

Ellis, Bret Easton. "Notes on Charlie Sheen and the End of Empire." *The Daily Beast* (15 March 2011), http://www.thedailybeast.com/articles/2011/03/16/bret-easton-ellis-notes-on-charlie-sheen-and-the-end-of-empire.html (accessed on 18 December 2014).

Flaubert, Gustave. *Madame Bovary.* Paris: Gallimard, 2001.

Gallope, Michael, Brian Kane, Steven Rings, James Hepokoski, Judy Lochhead, Michael J. Puri, and James R. Currie. "Vladimir Jankélévitch's Philosophy of Music." *Journal of the American Musicological Society* 65/1 (Spring 2012): 215-256.

Gursky, Andreas. *Andreas Gursky: Works 80-08.* Ed. Martin Hentschel. Hatje Cantz, 2011.

Hegel, Georg Wilhelm Friedrich. *Aesthetics: Lectures on Fine Arts, vol. 1.* Trans. TM Knox. Oxford: Clarendon, 1975.

— —. *Science of Logic.* Trans. AV Miller. New York: Humanity Books, 1969.

Herodotus, *Histories.* Trans. Aubrey de Sélincourt. London: Penguin, 2003.

Houellebecq, Michel. *La possibilité d'une île.* Paris : Fayard, 2005.

Hume, David. *A Treatise of Human Nature.* Book II, Part III, Section III. http://www.gutenberg.org/files/4705/4705-h/4705-h.htm (accessed 19 December 2014).

Isidore of Seville. *The Etymologies of Isidore of Seville.* Trans. Stephen A. Barney, W.J. Lewis, J.A. Beach, and Oliver Berghof. Cambridge: Cambridge University Press, 2006.

Jankélévitch, Vladimir. *Music and the Ineffable.* Trans. by Carolyn Abbate. Princeton, NJ: Princeton University Press, 2003.

Krasznahorkai, László. *The Melancholy of Resistance.* Trans. George Szirtes. New York: New Directions, 2000.

Lange, Susanne. *Bernd and Hilla Becher: Life and Work.* Trans. Jeremy Gaines. Cambridge, Mass: MIT Press, 2006.

Long, Christopher P. *Aristotle on the Nature of Truth.* New York: Cambridge University Press, 2011.

Meillassoux, Quentin. *After Finitude: An Essay on the Necessity of Contingency.* London: Continuum, 2008.

Morton, Tim. *Hyperobjects: Philosophy and Ecology After the End of the World.* Minneapolis: University of Minnesota Press, 2013.

— —. *The Ecological Thought.* Cambridge, MA: Harvard University Press, 2012.

Mulgan, Tim. *Ethics for a Broken World: Imagining Philosophy After Catastrophe.* Montréal: McGill-Queen's University Press, 2011.

Negarestani, Reza. *Cyclonopedia: Complicity with Anonymous Materials.* Victoria, Australia: Re.press, 2008.

The New American Bible. Iowa Falls: World Bible Publishers, 1987.

Pächt, Otto. *Book Illumination in the Middle Ages: An Introduction.* Trans. Kay Davenport London: Harvey Miller, 1986.

Pascal, Blaise. *Pensées.* Ed. Michel Le Guern. Paris : Éditions Gallimard, 2007.

Plato. *Gorgias.* In *Complete Works.* Ed. John M. Cooper. Trans. G.M.A. Grube. Rev. C.D.C. Reeve Indianapolis: Hackett, 1997.

— —. *The Republic.* In *Complete Works.* Ed. John M. Cooper. Trans. G.M.A. Grube. Rev. C.D.C. Reeve. Indianapolis: Hackett, 1997.

Pliny the Elder. *Natural History: A Selection.* Trans. John F. Healy. London: Penguin, 1991.

Pseudo-Dionysius. *The Complete Works.* Trans. Colm Luibheid. New York: Paulist Press, 1987.

Sebald, W.G. *The Rings of Saturn.* Trans. Michael Hulse. New York: New Directions, 1998.

Shelley, Percy Bysshe. *Laon and Cythna.* In *The Major Works.* New York: Oxford University Press, 2003.

Shute, Nevil. *On the Beach*. New York: Vintage, 2010.

Sturluson, Snorri. *Edda*. Trans. Anthony Faulkes. London: Everyman, 1987.

Swensson, Andrea. "The audacity of Low: What does a band 'owe' us when we pay to see them perform?" *The Current* (18 June 2013). http://blog.thecurrent.org/2013/06/the-audacity-of-low-what-does-a-band-owe-us-when-we-pay-to-see-them-perform/ (accessed 9 December 2014).

Vidal, Gore. *Julian*. New York: Vintage, 1992.

Virilio, Paul. "A Pitiless Art." In *Art and Fear*. Trans. Julie Rose , 27-65. London: Continuum, 2003.

Williams, John. *The Illustrated Beatus: A Corpus of the Illustrations of the Commentary on the Apocalypse*. Harvey Miller, 1994.

Discography and Videography

William Basinski. *The Disintegration Loops*. Discs 1-4. Musex 2001. 20620202, 20620202, 20620304, 20620305.

— —. *Melancholia*. Temporary Residence, 2014. TRR236.

— —. *The River*. Musex 2008. 20620702.

Boards of Canada. *Tomorrow's Harvest*. Warp 2013. WARPCD257.

Celer, *An Immensity Merely to Save Life*. https://celer.band camp.com/album/an-immensity-merely-to-save-life (accessed 29 December 2014).

— —. *Brittle*. Low Point, 2009. LP028.

— —. *Butterflies*. 2011. https://celer.bandcamp.com/album/ butterflies (accessed on 12 December 2014).

— —. *Engaged Touches*. Home Normal, 2009. home n002.

— —. *In Escaping Lakes*. Slow Flow Rec, 2009. WW1001.

— —. *Merkin*. 2009. https://celer.bandcamp.com/album/ merkin (accessed on 12 December 2014).

— —. *Panoramic Dreams Bathed in Seldomness*. Basses fréquences, 2010. BF27.

— —. *Salvaged Violets*. Infraction, 2010. INFX 050.

Dunn, Kyle Bobby. *A Young Person's Guide to Kyle Bobby Dunn*. Low Point, 2010. LP033.

Hecker, Tim. *An Imaginary Country*. Kranky 2009. Krank 130.

— —. *Harmony In Ultraviolet*. Kranky 2006. Krank 102.

— —. *Ravedeath, 1972*. Kranky 2011. Krank 154.

— —. *Virgins*. Warp 2013. Krank 183.

Köner, Thomas. *Novaya Zemlya*. Touch, 2011. TO:85.

— —. *Nunatuk – Teimo – Permafrost*. Type Recordings, 2010. TYPE 072.

Les Rallizes Dénudés. *Le 12 mars 1977 à Tachikawa*. Level Over [year unknown]. 001.

Low. "Do You Know How to Waltz?". Live at Rock the Garden

2013. https://www.youtube.com/watch?v=zI5-MuV5NSo (accessed 9 December 2014).

— —. *The Curtain Hits the Cast*. Plain Recordings, 1996. Plain 172-2.

Manufactured Landscapes, dir. Jennifer Baichwal. Zeitgeist Films, 2006.

Morrissey. *Viva Hate*. HMV 1988. 064 790180 1.

Radigue, Éliane. *Adnos I-III*. Important Records, 2013. IMPREC 028.

— —. *L'île ré-sonante*. Shiin, 2005. Shiin 1.

— —. *Jetsun Mila*. Lovely Music, 2007. LCD 2003.

Stereolab. *Transient Random-Noise Bursts With Announcements*. Elektra 1993. 9 61536-2.

"The Deepwater Horizon spill 27th-28th May 2010". https://www.youtube.com/watch?v=1DefFP6dezA (accessed 29 July 2014).

U.S. Debt Clock". http://www.usdebtclock.org/ (accessed 29 July 2014).

Contemporary culture has eliminated both the concept of the public and the figure of the intellectual. Former public spaces – both physical and cultural – are now either derelict or colonized by advertising. A cretinous anti-intellectualism presides, cheerled by expensively educated hacks in the pay of multinational corporations who reassure their bored readers that there is no need to rouse themselves from their interpassive stupor. The informal censorship internalized and propagated by the cultural workers of late capitalism generates a banal conformity that the propaganda chiefs of Stalinism could only ever have dreamt of imposing. Zer0 Books knows that another kind of discourse – intellectual without being academic, popular without being populist – is not only possible: it is already flourishing, in the regions beyond the striplit malls of so-called mass media and the neurotically bureaucratic halls of the academy. Zer0 is committed to the idea of publishing as a making public of the intellectual. It is convinced that in the unthinking, blandly consensual culture in which we live, critical and engaged theoretical reflection is more important than ever before.

ZERO BOOKS

If this book has helped you to clarify an idea, solve a problem or extend your knowledge, you may like to read more titles from Zero Books. Recent bestsellers are:

Capitalist Realism Is there no alternative?
Mark Fisher
An analysis of the ways in which capitalism has presented itself as the only realistic political-economic system.
Paperback: November 27, 2009 978-1-84694-317-1 $14.95 £7.99.
eBook: July 1, 2012 978-1-78099-734-6 $9.99 £6.99.

The Wandering Who? A study of Jewish identity politics
Gilad Atzmon
An explosive unique crucial book tackling the issues of Jewish Identity Politics and ideology and their global influence.
Paperback: September 30, 2011 978-1-84694-875-6 $14.95 £8.99.
eBook: September 30, 2011 978-1-84694-876-3 $9.99 £6.99.

Clampdown Pop-cultural wars on class and gender
Rhian E. Jones
Class and gender in Britpop and after, and why 'chav' is a feminist issue.
Paperback: March 29, 2013 978-1-78099-708-7 $14.95 £9.99.
eBook: March 29, 2013 978-1-78099-707-0 $7.99 £4.99.

The Quadruple Object
Graham Harman
Uses a pack of playing cards to present Harman's metaphysical system of fourfold objects, including human access, Heidegger's indirect causation, panpsychism and ontography.
Paperback: July 29, 2011 978-1-84694-700-1 $16.95 £9.99.

Weird Realism Lovecraft and Philosophy

Graham Harman

As Hölderlin was to Martin Heidegger and Mallarmé to Jacques Derrida, so is H.P. Lovecraft to the Speculative Realist philosophers.

Paperback: September 28, 2012 978-1-78099-252-5 $24.95 £14.99.

eBook: September 28, 2012 978-1-78099-907-4 $9.99 £6.99.

Sweetening the Pill or How We Got Hooked on Hormonal Birth Control

Holly Grigg-Spall

Is it really true? Has contraception liberated or oppressed women?

Paperback: September 27, 2013 978-1-78099-607-3 $22.95 £12.99.

eBook: September 27, 2013 978-1-78099-608-0 $9.99 £6.99.

Why Are We The Good Guys? Reclaiming Your Mind From The Delusions Of Propaganda

David Cromwell

A provocative challenge to the standard ideology that Western power is a benevolent force in the world.

Paperback: September 28, 2012 978-1-78099-365-2 $26.95 £15.99.

eBook: September 28, 2012 978-1-78099-366-9 $9.99 £6.99.

The Truth about Art Reclaiming quality

Patrick Doorly

The book traces the multiple meanings of art to their various sources, and equips the reader to choose between them.

Paperback: August 30, 2013 978-1-78099-841-1 $32.95 £19.99.

Bells and Whistles More Speculative Realism

Graham Harman

In this diverse collection of sixteen essays, lectures, and interviews Graham Harman lucidly explains the principles of

Speculative Realism, including his own object-oriented philosophy.
Paperback: November 29, 2013 978-1-78279-038-9 $26.95 £15.99.
eBook: November 29, 2013 978-1-78279-037-2 $9.99 £6.99.

Towards Speculative Realism: Essays and Lectures Essays and
Lectures
Graham Harman
These writings chart Harman's rise from Chicago sportswriter to
co founder of one of Europe's most promising philosophical
movements: Speculative Realism.
Paperback: November 26, 2010 978-1-84694-394-2 $16.95 £9.99.
eBook: January 1, 1970 978-1-84694-603-5 $9.99 £6.99.

Meat Market Female flesh under capitalism
Laurie Penny
A feminist dissection of women's bodies as the fleshy fulcrum of
capitalist cannibalism, whereby women are both consumers and
consumed.
Paperback: April 29, 2011 978-1-84694-521-2 $12.95 £6.99.
eBook: May 21, 2012 978-1-84694-782-7 $9.99 £6.99.

Translating Anarchy The Anarchism of Occupy Wall Street
Mark Bray
An insider's account of the anarchists who ignited Occupy Wall
Street.
Paperback: September 27, 2013 978-1-78279-126-3 $26.95 £15.99.
eBook: September 27, 2013 978-1-78279-125-6 $6.99 £4.99.

Find more titles at www.zero-books.net